BLAYDON & WINLATON

THROUGH TIME

Nick Neave & Susan Lynn

AMBERLEY PUBLISHING

Acknowledgements

In no particular order the authors would like to express their thanks to the following individuals and organisations that have contributed to this book:

David Lynn
Dennis Young and Linda Barlow from Blaydon Rugby Football Club
Charles Scott of Dower House
Patrick Sheridan from Sheridan Designs
Kurt Riffert from Oakleystone Northern
Members of Winlaton & District Local History Society

Ownership of the photographs is as follows:

All of the 'new' photographs were taken by the authors during 2012.
Blaydon Rugby Football Club provided the 'old' photographs on pages 6, 28 & 56.
Gateshead Council supplied the 'old' photographs on pages 7 & 8.
Dr Tom Yellowley supplied the old photographs on pages 37 & 44.
Winlaton & District Local History Society provided all other 'old' photographs.

First published 2012

Amberley Publishing
The Hill, Stroud
Gloucestershire, GL5 4EP

www.amberley-books.com

Copyright © Nick Neave & Susan Lynn, 2012

The right of Nick Neave & Susan Lynn
to be identified as the Authors of this work has been
asserted in accordance with the Copyrights, Designs
and Patents Act 1988.

ISBN 978 1 4456 0289 9

British Library Cataloguing in Publication Data.
A catalogue record for this book is available from
the British Library.

Typeset in 9.5pt on 12pt Celeste.
Typesetting by Amberley Publishing.
Printed in the UK.

Introduction

The towns of Blaydon and Winlaton, and the nearby settlements of Stella and Winlaton Mill are located around 5 miles from Newcastle-upon-Tyne. They are relatively small places now, but in their time were vital components of the industrial machine that was so important to the development of Tyneside.

Chapter 1 features Blaydon (or Blaydon-on-Tyne, to give it its official name) and Stella. With its prime location on the River Tyne, this area formed a key transport link for the lead mined in Weardale, and the coal hewed in nearby Winlaton, to be delivered by the keelmen to the larger vessels in Newcastle, and thence to far-flung places. Blaydon also had industries of its own, thriving coal mines, a fire brick works and several ironworks. Railway links to Newcastle and Carlisle, and road links to Hexham and Newcastle also enabled this small town to develop and thrive. Much of the old Blaydon has now vanished, the industries have long since disappeared, and the transport links bypassed to some extent, but the town lives on thanks to a former miner turned song writer and music hall artist George (Geordie) Ridley (1835–1864). In 1862 George wrote a song called 'The Blaydon Races', based upon his experiences of travelling from Newcastle to the famous horse races and fair held at Blaydon the previous year. The song was first performed at Mr Balmbra's Royal Music Saloon at the Wheat Sheaf Inn located in Newcastle's Cloth Market on 5 June 1862. The event was a testimonial for Harry Clasper the famous Tyneside oarsman and Geordie's rendition of 'The Blaydon Races' served to advertise his forthcoming appearance at Blaydon on 9 June, and to promote the forthcoming horse racing event. The song is now regarded as the anthem of Tyneside and is raucously sung by Newcastle United's loyal fans:

Ah me lads, ye shud 'ave seen us gannin',
We pass'd the foaks upon the road just as they wor stannin';
Thor wes lots o' lads an' lasses there, all wi' smiling faces,
Gannin' alang the Scotswood Road, to see the Blaydon Races.

Stella (originally called 'Stelyngleye') is part of the ancient parish of Ryton, and once half owned by the nuns of St Bartholomew. Coal was also mined at Stella and at the haughs (riverside meadow) alongside the River Tyne various cargos were dispatched to Newcastle.

Chapter 2 covers the other key town Winlaton, a town with a much older recorded history and one that is also strongly associated with industry, especially that of coal mining and iron working. The Boldon Book written in 1183 refers to Wynlaktona; a few hundred years later the name of Wynlatone had been adopted and here commence the historical records that attest

to the existence of coal mining in the area. At this time we also hear about the links with the powerful Neville family, originating from Staindrop in County Durham, who owned much of the local land and industries. Also strongly associated with Winlaton are the Clavering and Cowen families, industrialists whose names are closely linked with the industrial development of Tyneside. In addition we have the giant of industry Sir Ambrose Crowley (1658–1713) who brought his ironworks to the area in 1691 along with his loyal workforce called 'Crowley's crew'. Crowley's innovative working practices aimed at improving worker education, health and job satisfaction would not be out of date in today's workforce. After the decision to move the ironworks to nearby Winlaton Mill and Swalwell, the town of Winlaton began to decline, and has never fully recovered its glorious industrial past.

These towns/settlements have changed considerably from their industrial heydays and the imprint of these now defunct industries is beginning to fade on the landscape; soon there will be little evidence that mighty industries were located in these places. It is true to say though that their industrial legacy still remains in the hearts and minds of the people of the North East.

The aim of this book is to preserve the industrial and social heritage of these places before they become long forgotten by showing the reader an old photograph alongside a current picture taken in the same spot (or as close as possible). We hope that by showing the old alongside the new the reader can gain an impression of how their community has altered (or not) over the years.

<div align="right">Nick Neave and Susan Lynn, March 2012</div>

As a former miner I have deep respect for the culture and people who shaped our region. Part of our heritage is the huge array of trade union banners that we see flying at the 'Durham Big Meeting' every year. One of the most frequently used slogans on the banners are the words 'The past we inherit – the future we build'. I passionately believe in those words and books such as this one play a huge role in reminding us from whence we came, and may just give us the impetus to face up to the challenges of today in the same brave and fearless way that those who went before us did.

They faced desperate conditions at home and work and they built a world to be proud of. We face global challenges of a vastly different nature but that same self belief and confidence can help us to improve our lot in life and make a better world for those who will follow us on. If nothing else, our history should be preserved by us for our children and theirs because we come from great stock.

<div align="right">Dave Anderson MP for Blaydon, March 2012</div>

CHAPTER 1

Blaydon

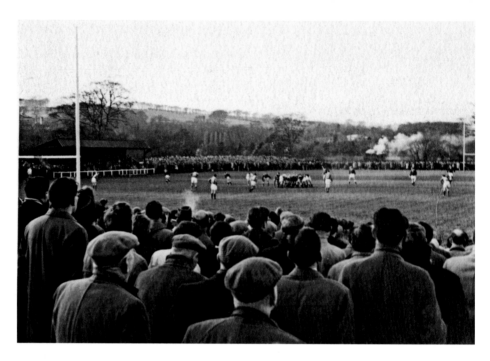

'Up and Under'

Blaydon Rugby Football Club began life as Blaydon Star in 1888 and initially played in the grounds of Stella Hall. The club steadily expanded and by 1892 the now-named Blaydon RFC could field three teams. A year later the club moved to Blaydon Race Course on Stella Haughs, and then to an area called 'The Spike', where the club remained until 1951. When the area was purchased by the Electricity Board the club moved to Crow Trees on Hexham Road, Swalwell. The picture above shows a county game at Crow Trees in the 1950s; Axwell Hall can be glimpsed in the background as can a steam engine. The new picture was taken on Saturday 18 February 2012 when Blaydon (in red and black) played host to Ealing Trailfinders in a National League One match, the home side winning 12–10.

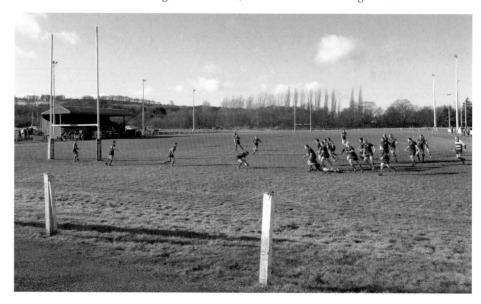

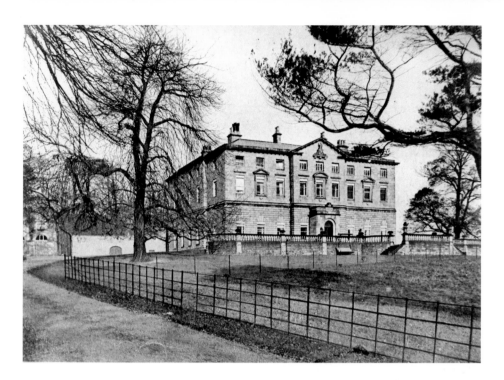

Axwell Hall

Axwell was the name given to a manor held from the Bishop of Durham by William de Birtley. It passed to various families including the Redheugh's, Shafto's and Lumley's, and then in 1629 was purchased by James Clavering, a prominent Newcastle merchant who constructed Axwell House. In 1758 one of his descendants Sir Thomas Clavering (1719–94) replaced the old house with Axwell Hall, designed by architect James Paine (1712–89) in the Palladian style (a form of architecture named after Venetian architect Andrea Palladio who was influenced by classical Greek and Roman temples). The estate was sold in 1920 and it ended its functional life as Newcastle Boys Industrial School. The hall stood empty for many years but was acquired by property developers in 2006 and is currently being restored as separate apartments.

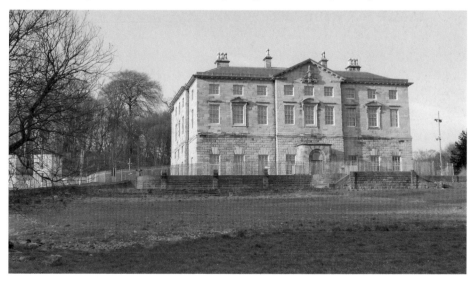

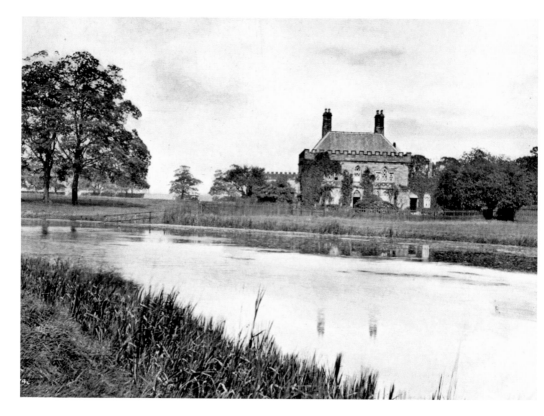

A Family Seat

Axwell Villa (also called 'Dower House') is a stone built house situated on Shibdon Road built between 1770–1780 by James Paine. The carriage drive wound through the ancient trees of a deer park, passing an ornamental lake and bridge, the curve of the drive then giving a splendid vista of the house. The old photograph was taken from a sale catalogue for the auctioning of Axwell Park in 1920. The current owner is Mr Charles Scott who was born in the house in 1927. Note the left wing of the house (the old stable block) has been raised.

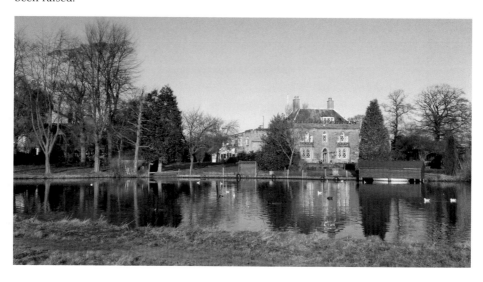

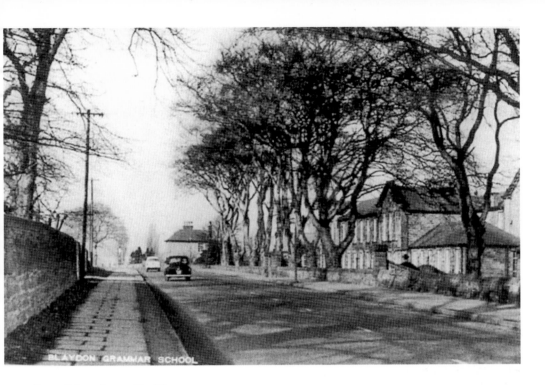

From Education to Health

Blaydon Secondary School was built in 1912 and became a Grammar School following the 1944 Education Act. Blaydon Comprehensive School was created in 1971 merging with Blaydon East County Secondary School, with this being the main site. Following the loss of the sixth form and a falling school roll the school closed in 1998, and the building was demolished in 2000. The Blaydon Leisure and Health Centre which opened in 2010 now covers this site. An original stone pillar can just be seen behind the lamppost and provides the reference, as does the tree on the right. The wall on the left is unchanged.

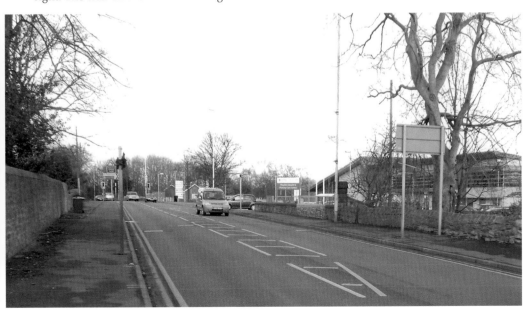

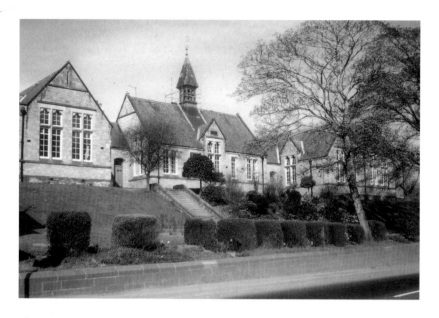

Blaydon East

This school opened in 1891 as Blaydon Board School. In 1929 Blaydon East Senior Boys and Senior Girls merged to form Blaydon Council Intermediate. Following the 1944 Education Act the school's name was changed again to Blaydon East County Secondary Modern. In 1967 the school merged with Winlaton County Secondary Modern Mixed to form a first stage comprehensive school. The change to fully comprehensive education was completed in 1971 with the merger of Blaydon East with Blaydon Grammar School to form Blaydon Comprehensive. 'Blaydon East' ceased to exist as a separate school but the new Comprehensive continued to operate on two sites, and the Blaydon East site became known as the 'Bank Department'. Only the low stone wall remains.

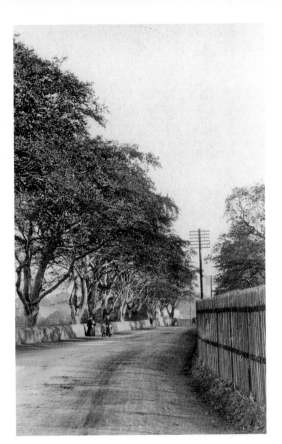

Shibdon Road

Shibdon Road connects Blaydon to Swalwell and it seen here around 1910. This image is from a series of postcards by Thomas E. Friars who initially ran a general dealer's on Murray Street and lived at number 57 Theresa Street, Blaydon. He took over a photography business from William Friars (probably his father) around 1914. The low stone wall on the left hand side still remains.

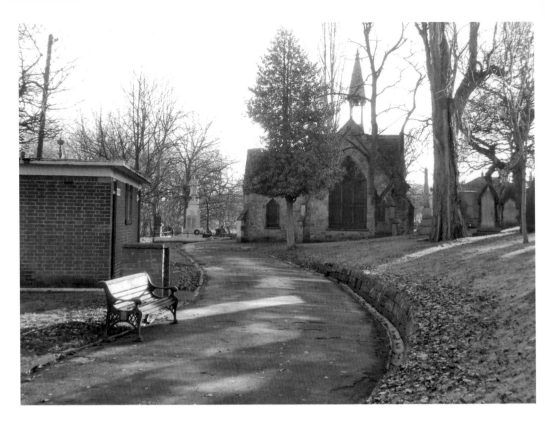

A Peaceful Spot

By the mid-nineteenth century, church graveyards were beginning to pose serious health risks due to overcrowding. The Burial Acts of 1852 and 1853 enabled local authorities to administer their own cemeteries. Parish vestries elected Burial Boards to manage them. Blaydon cemetery houses the grave and statue of Tommy Ramsey, one of the founders of the Durham Miners' Association, who died in 1873. His statue shows him with a roll of handbills and the rattle which he used to call miners to his meetings. The chapel remains but the building on the left has been replaced.

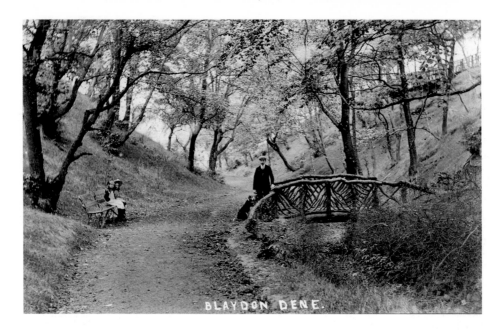

BLAYDON DENE.

The Dene

Shibdon Dene is a natural gorge that was developed as an area for genteel leisure by Blaydon Urban District Council around 1900. The site originally had a park keeper and was well maintained: seats were placed along its length, a drinking fountain provided refreshment and a large heated shelter was created. Over the years it fell into neglect until the 'Friends of Shibdon Dene' working with Gateshead Council obtained funding to improve the site in 2005. It is now home to grey squirrels and is a favourite spot for local dog walkers. The bridge and small stream have gone but this is approximately the same location.

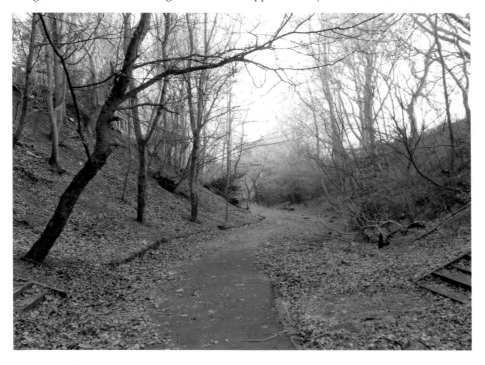

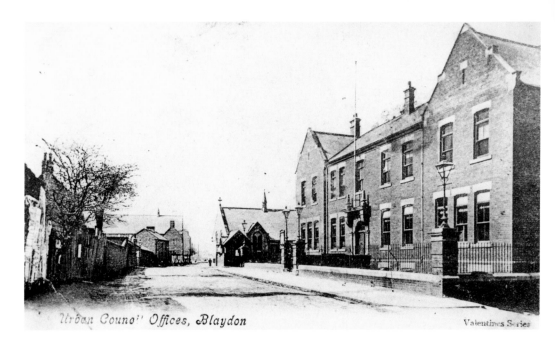

Urban Council Offices, Blaydon Valentines Series

Council Offices

Blaydon was administered by a local board, established in 1861, until the foundation of the Urban District Council in 1894 with Colonel John Cowen acting as chairman. The first clerk was J. Dalton, whose family owned a brewery at Stella, and the Council was housed in Tyne Street. The Council was reknowned for being forward-thinking and was one of the few authorities to have a sewage works; it also established bus inspectors and leased a fire brigade from nearby Newburn. During the depression of the 1920s and 1930s the Council set up soup kitchens and adopted a system of giving each unemployed man eight weeks work, assisting on various labouring projects.

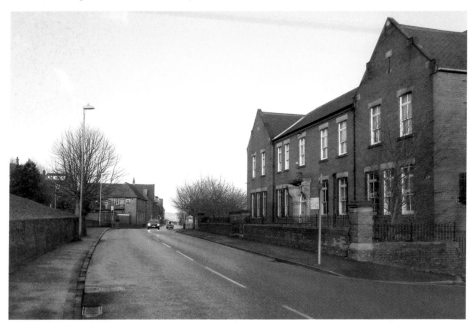

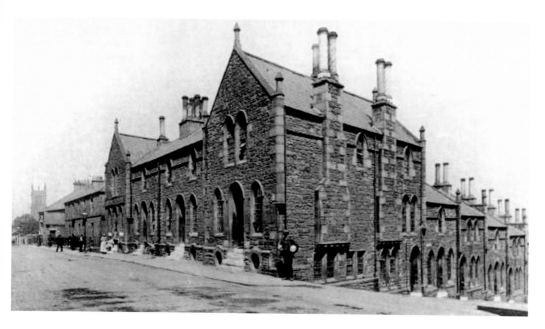

The Vanished Terrace

This splendid looking row of buildings stood on Shibdon Road opposite the Bisley at the junction with Robinson Street. Records are not clear as to what these buildings were, though they are clearly too grand to be just housing. Much of this area of Blaydon was demolished before 1962 as part of the demolition of unfit houses, and the residents moved to the new council estates of Winlaton and Blaydon.

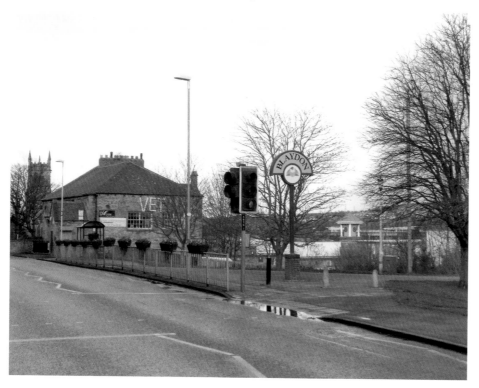

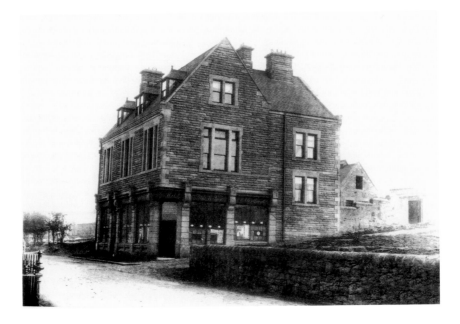

The Bisley

The Bisley Hotel opened in 1894 after the Beehive Public House on Bridge Street closed, and the licence was transferred. The last landlord of the Beehive and the first at the Bisley was Edward Adams, a noted rifle marksman who probably named the pub after the town of Bisley in Surrey, home of the National Rifle Association since 1890, and where he is known to have competed. When first built, the pub stood in splendid isolation but it now has buildings either side. The building is noted for its original bar fittings and furniture. Current landlord is Steve Ronchetti, a councillor for Blaydon.

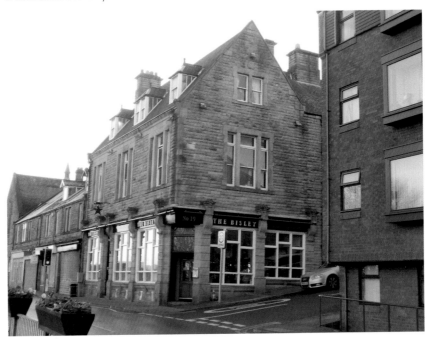

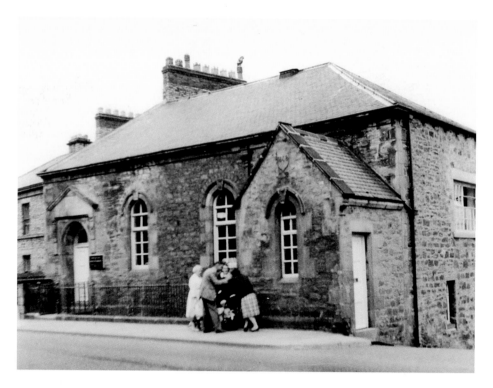

Library

Originally built as a Primitive Methodist Chapel, this building later became well known as Blaydon Library. It is pictured above in 1961. Converted to modern use it has been used as a dance studio, the ground floor is now a hairdresser and the lower floor is used by a veterinary surgeon.

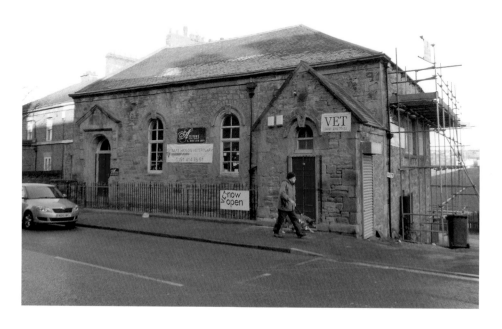

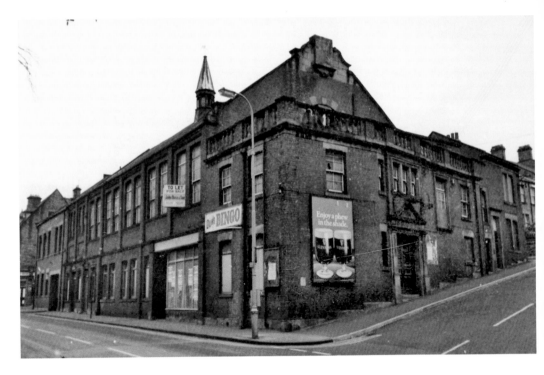

The Pavillion

The Pavillion cinema was situated on the corner of Shibdon Road and West View; it is pictured here in 1977. The Pavilion was known to all in Blaydon as 'The Hall' and was the venue for Blaydon's very own silent movie *Whe Stole the Boots*, an action-packed film about a chase through the streets of Blaydon following the theft of a pair of boots and which ended with the cast all falling into the River Tyne. It was demolished and the current building is a series of apartments. The houses on West View can still be recognised.

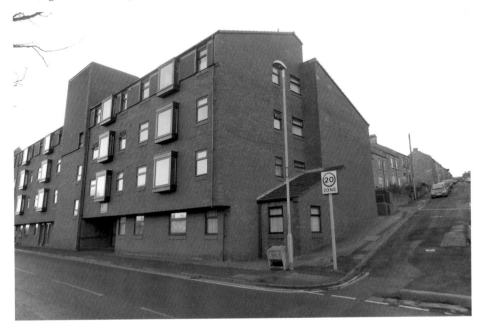

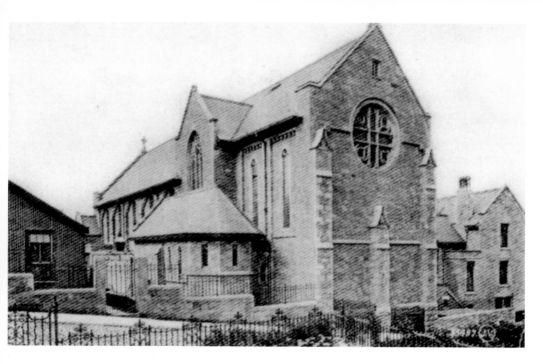

St Joseph's

In the nineteenth century the population of Blaydon expanded rapidly and many of the new residents were Irish Catholic immigrants fleeing the famine. They initially worshipped at St Thomas Aquinas at Stella, but this was too small, and so in 1903 St Joseph's was built. The church was finally dedicated in 1930 when the outstanding debt was cleared.

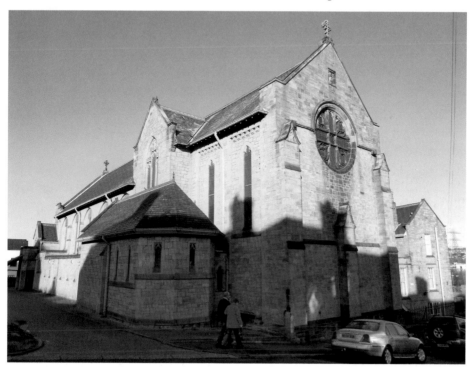

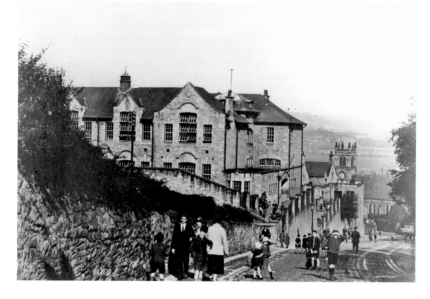

Silver Hill

Branching off to the left of Shibdon Road is Blaydon Bank, pictured in the 1930s. In the 1780s this street was the main road to Winlaton, and the pack horses would plod down hauling their large baskets filled with lead, on their way from the mines of Allenheads in Northumberland to the lead works in Blaydon. It was not an uncommon sight to see forty or fifty horses, led by two men, snaking their way down this street to the river, the lead horse wearing a bell on its head to guide the rest. As every ton of lead ore also produces around 9/10 ounce of silver, this route was called 'Silver Hill'. The large building on the left is Blaydon West School built in 1909. The girls were educated upstairs and the boys downstairs.

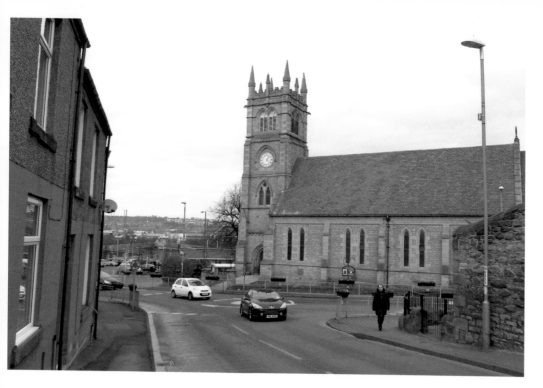

Blaydon Bank

This is the foot of Blaydon Bank with Shibdon Road leading off to the left and the right, and Church Street in the centre. Note how in the old drawing the road is unpaved, and rutted because of the cart wheels. The terrace to the left and the church hall on the right hand corner are still in existence, with the sloping roof and small wall clearly visible.

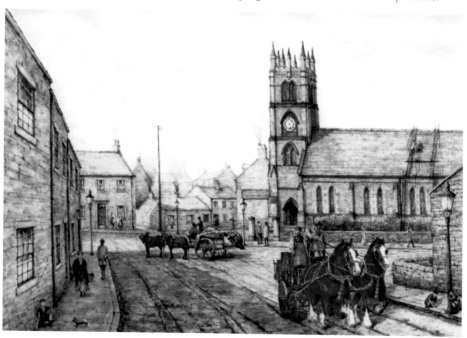

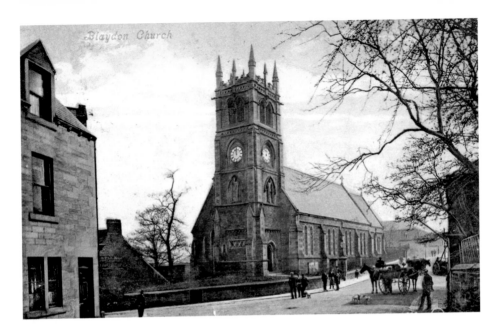

St Cuthbert's Church

St Cuthbert's, Winlaton Parish (including Blaydon), was formed from Ryton Parish in 1832, and Blaydon became a separate parish under the name of St Cuthbert, Stella, in August 1844. The nave and south porch of St Cuthbert's were erected in 1844 and the north aisle, chancel and tower were added later. In 1876 six bells and a clock were positioned in the tower, the money for their erection being made by subscription. In 1882 work was carried out to remove the south porch, replace pews and move the organ to the chancel. Since 2003 St Cuthbert's has been joined by Holy Trinity Church, Swalwell, to form the Parish of Blaydon & Swalwell.

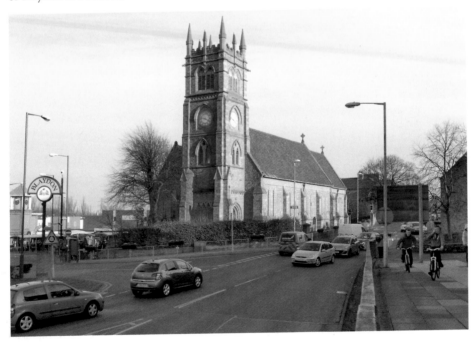

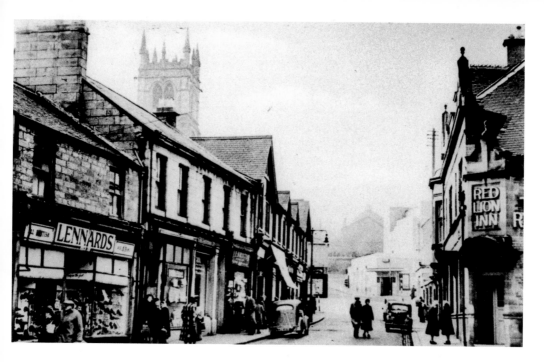

Church Street

Looking up Church Street towards St Cuthbert's Church. Lennards the shoe shop is on the left hand side and the corner of the Red Lion Inn on Wesley Place is on the right. The original centre of Blaydon lay further west along Bridge Street but as the railway and coal mines expanded in the early nineteenth century the town expanded, and a new centre developed near St Cuthbert's. This area was demolished in the 1970s to make way for a new shopping centre and bus interchange.

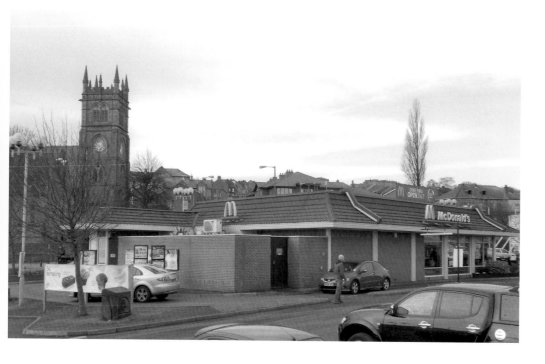

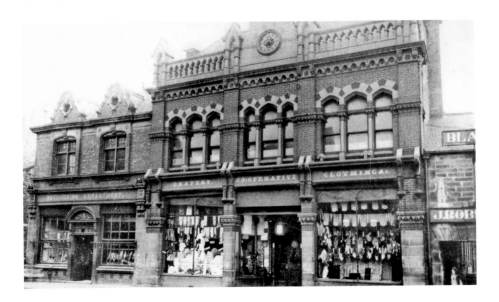

First in the North!

The name of Joseph Cowen junior (1829–1900) is firmly associated with the politcal and industrial landscape of the North East. He was born in Winlaton and gained his industrial credentials working for his father's brick works in Blaydon. He was a radical politician, once entertaining the Italian revolutionary Garibaldi at his home. He was an enthusiastic supporter of Holyoake's book on the Rochdale Co-operative Store (*Self Help by the People*) and inspired by his passion, the first Co-operative in the North East was established in Cuthbert Street, just off Shibdon Road, Blaydon, in 1858, with thirty-eight members. This section of the new shopping centre is in approximately the same location as the Church Street Co-operative Store.

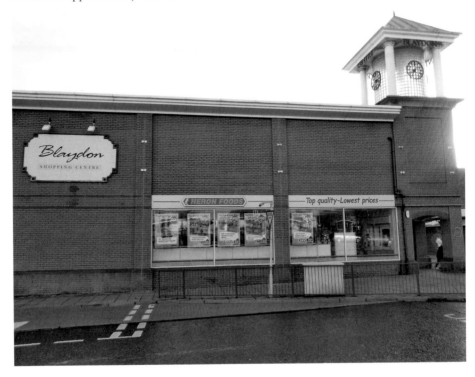

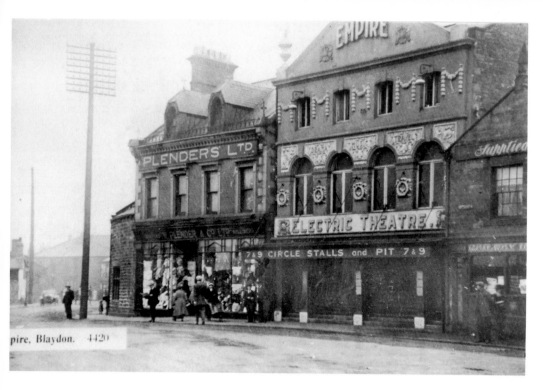

pire, Blaydon. 4420

The Empire

The Empire Theatre pictured above around 1915. It was built as an Electric Theatre in the style of the music hall with stalls, circle and pit. A piano played from under the screen to accompany the first silent films shown here. The Empire eventually became a branch of Woolworth's but never lost its wooden raked floor from its cinema days. It was demolished with the rest of the town centre in 1972; left is Plender's drapery, and on the right is the Railway Inn. Comparing new and old maps confirms that this is the approximate location.

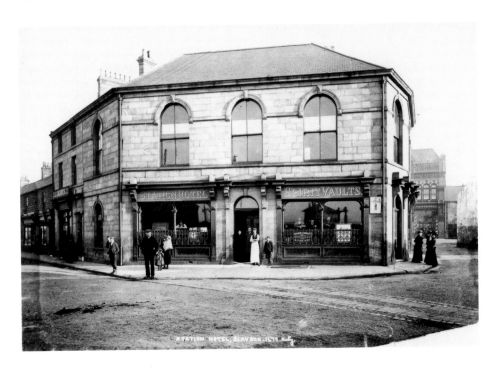

Station Hotel

The Station Hotel was situated on Tyne Street opposite the railway station. In later years the pub was supplied by Robert Deuchar Ltd. Robert Deuchar (1831–1904) came to the North East from Forfarshire in the 1860s with his three brothers to work as an innkeeper. He purchased a brewery on Sandyford Lane in 1892 and by 1900 he owned forty licensed inns on Tyneside. The company was bought by Newcastle Breweries in 1953. The exact site is now in the middle of a busy dual carriageway.

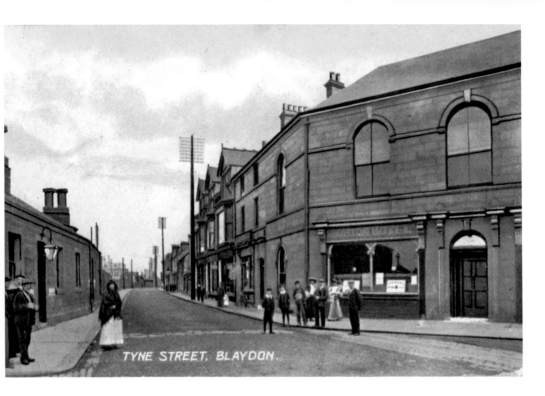

TYNE STREET, BLAYDON.

Tyne Street

Looking down Tyne Street, the railway station is on the left, and the Station Hotel can be seen on the right. Parts of the wall on the left still exist but the entire area was demolished to make way for the dual carriageway that links Blaydon with Newcastle (via a bridge over the Tyne) and Gateshead, a footbridge now being vital to gain access to the town centre.

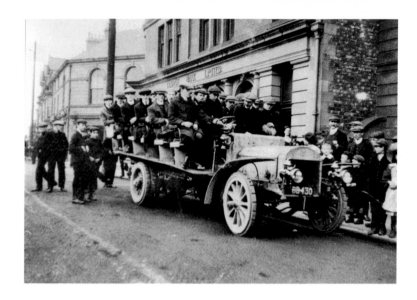

The Away Match

Pictured above are members of Blaydon RFC sitting in their charabanc about to leave to play the Scottish champions Jedbergh on 24 September 1910. The team met outside Lloyd's Bank, Blaydon; in the background is the Station Hotel, the club's headquarters for many years. Third from left is R. B. Cairns (nicknamed 'Dobbin'), who became the club's first full county player. Modern players would no doubt be appalled at the primative transport and you wonder what state the players arrived at their match after a long journey in an open-sided vehicle with no proper suspension! Here in the approximate location are three current members of Blaydon's squad; from left to right David Sheldon, Andrew Welsh and Daniel Sanderson.

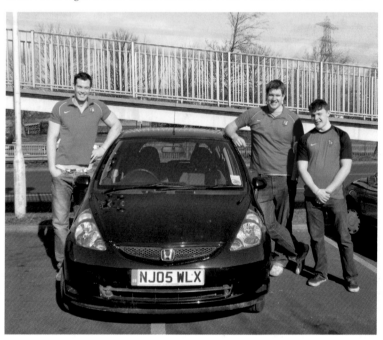

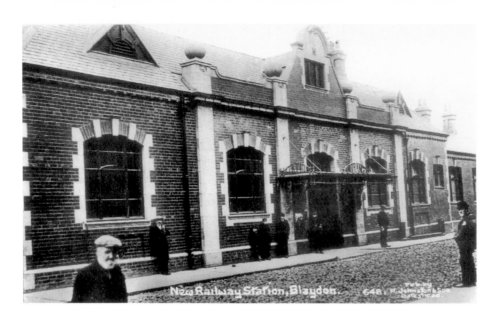

Blaydon Station

Above is Blaydon railway station completed in 1914. Work on a new railway linking Newcastle to Carlisle began in March 1830, and by November 1834 the section of that line between Blaydon and Hexham was complete. On 9 March 1835 the line was opened for passenger traffic, and a cermonial excursion was laid on for 600 guests filling 2 trains, each hauling 3 carriages. The average speed from Hexham to Blaydon was estimated at 15 mph. A regular passenger service began the following day. The wooden station was redeveloped in 1881 after complaints by the local health board; the Victorian stone-built station was replaced in 1912.

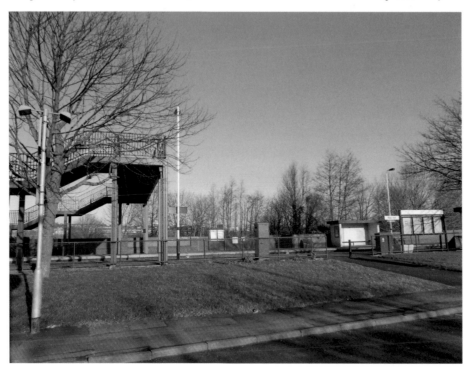

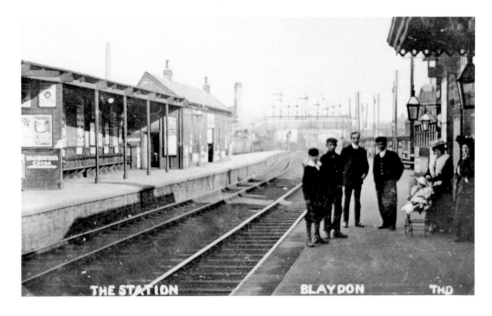

Waiting for a Train

Another view of the station, taken around 1900. Travellers from Hexham wishing to visit Newcastle had to disembark at Blaydon and then take a coach for the final stage of their journey. Later the line was extended to Redheugh on the south bank of the Tyne where they would then take a steam ferry across the river to Newcastle. The station opened railway sheds alongside Chainbridge Road in 1900, and they housed around fifty engines. By 1934 the sheds were holding eighty-four engines. Steam engines were withdrawn in 1963 and the sheds closed in 1965. The station closed in 1966 but was reprieved, becoming an unstaffed station in 1969.

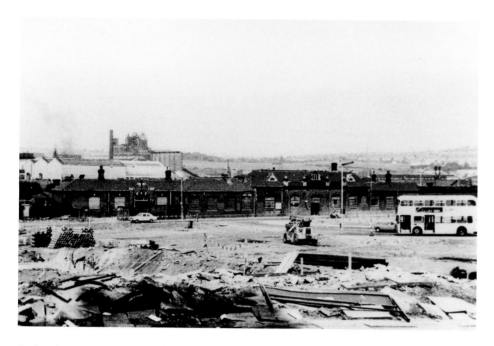

Redevelopment

In the 1970s Blaydon Urban District Council made the decision to completely redevelop the town centre. Demolition began with the streets north of Shibdon Road, Cuthbert Street, Robinson Street, Thomas Street and James Street being the first to go. This was followed by the demolition of the streets and traditional shopping area around Wesley Place in favour of a modern road system and shopping precinct. The large industrial building in the background was the graphite factory at Newburn, and the newer grey building left centre above the white walls of the shopping centre is on the site of the graphite factory.

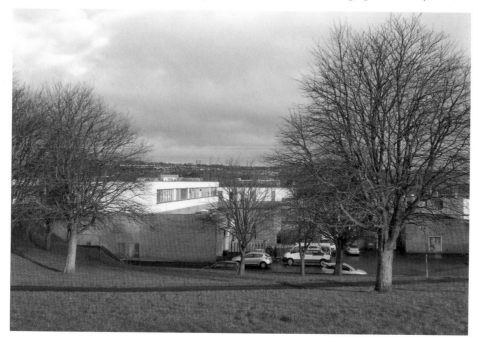

The Geordie Ridley

When the town centre of Blaydon was redeveloped, a centrepiece was the Geordie Ridley public house, pictured above in 1980. It was named after the famous Tyneside Music Hall performer and songwriter George 'Geordie' Ridley. He was a miner's son, born in Gateshead in 1835 and began work as a 'trapper' at Oakwellgate Colliery at the tender age of eight. After an accident whilst riding a loaded coal waggon he was forced to rely on his voice and his wit, and he became a popular performer. He sadly died at the age of twenty-nine just two years after composing his most famous work the Tyneside Anthem that is the *Blaydon Races*. Very little has changed in the last thirty-two years.

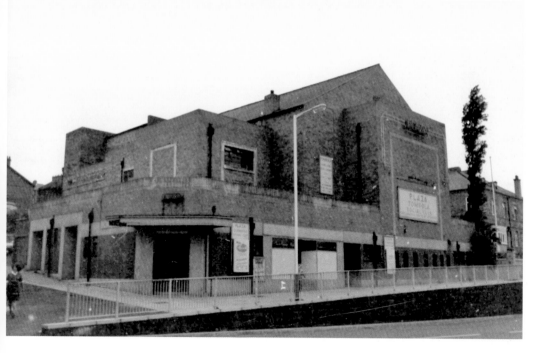

The Plaza

The Plaza cinema stood on Garden Street and is pictured here in 1971. It was built in 1936 during the heyday of the cinema, and was one of three cinemas in Blaydon. The cinemas drew their audience from Blaydon and the surrounding areas with people often going to the pictures twice per week. The Plaza closed in 1968 and became a Bingo Hall. It was demolished in 2005 and has been replaced by Hadrian House Care Home.

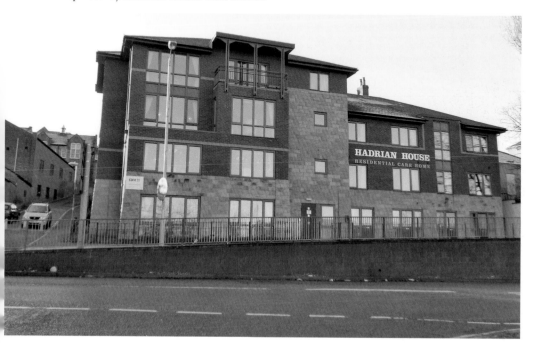

Blaydon House

This fine Georgian house was the home of John Mulcaster the agent to T. R. Beaumont, later the home of Dr Brown, the Doctor in Blaydon at the time of the Blaydon Races. In the photograph we can see Dr Brown's carriage ready for his rounds. It was later used as Blaydon Conservative Club and presently stands empty awaiting a new owner to bring it back to life.

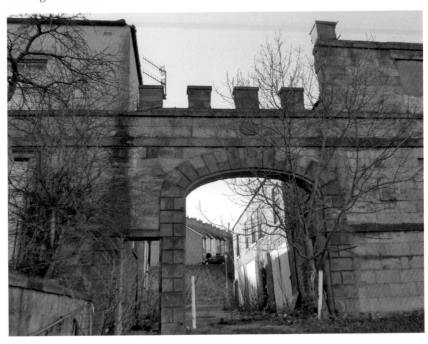

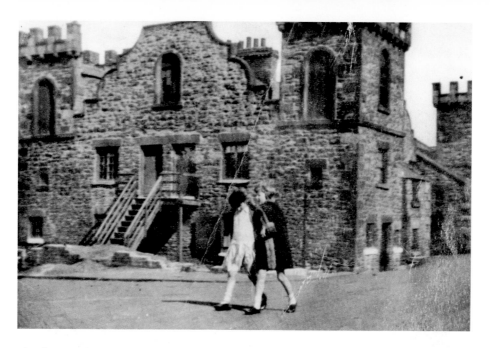

Blaydon Castle

The area of Blaydon Haughs alongside the river was known as 'the Spike', at one point a separate small village cut off from the rest of Blaydon by the railway line. 'Spike' was an Irish term for a lodging house and in the 1860s the area was home to numerous Irish families. The castle wasn't a castle as such, but was in fact a large castellated house built in the reign of Charles II, probably for the Selby family whom we know owned the land it stood on. After the Civil War the Selby family came upon hard times and gradually sold off their land in Blaydon; in 1800 the 'castle' was converted into tenements and housed twelve families, the house being apparently haunted by the ghost of Frances Selby! The castle was demolished in 1926 and this building (formerly the Bottle House Arms pub) built on the site in 1931.

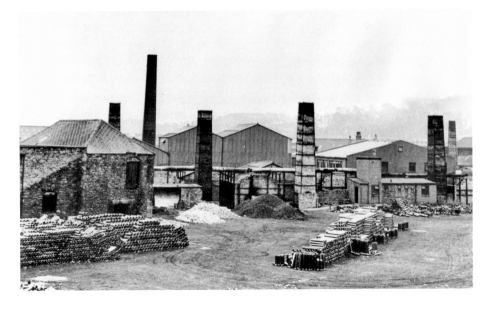

Harriman's

The firm of William Harriman & Company Limited was established in the 'Spike' in 1844, and was one of the longest surviving and most successful industries in Blaydon. In fact the company had begun some years earlier when a brickmaker John Sowler died in 1812 owing a large sum of money. The debt was taken over by greengrocer William Harriman and he ran the brickworks himself until 1847 when he joined forces with William Dodds. The firm operated as Dodds & Harrimans until 1867 when a new partnership was created, and the Limited Company was established in 1882. The main output of the company was fire glazed sinks, with the majorioty of the 600 or so produced each work for export abroad. An industrial estate now covers this site.

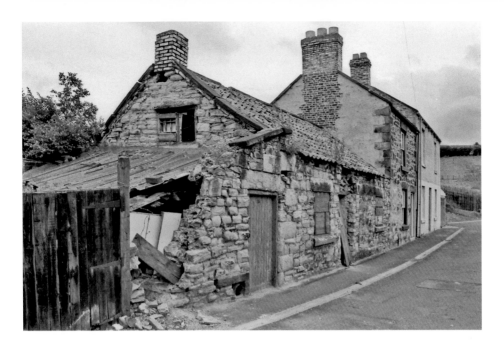

Horse Crofts

Before 1850 the Tyne could only be navigated by keels which were shallow draught boats, manned by a crew of two men and a lad and they shipped coal down river to larger vessels called 'collier brigs'. The keelmen were tough hard drinking men. They were given a 'can' or ale allowance of 12½ pence per keel and they were well known for their fighting skills; there was many a fight with the keelmen who frequented the Skiff at the mouth of the River Derwent. As a sport they enjoyed rowing, they were goods oarsmen and many built their own boats. The last keelman's cottage at Horse Crofts is now demolished but the last house in the row remains.

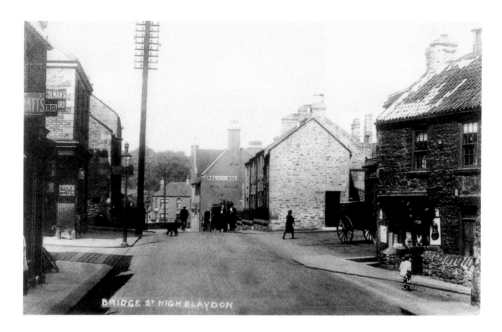

Bridge Street

This was the first area in Blaydon to be built, and was originally known as High Blaydon. Bridge Street (the Turnpike Road) leading down to the crossing over Blaydon burn housed a number of different properties before the building of the present road bridge in 1936. The little girl on the right is at the top of Gas Lane, in front of Marshall's grocery shop. The cart to the right is standing in front of the Black Bull. The distinctive gable of the New Inn centre background provides a reference point for the new photograph.

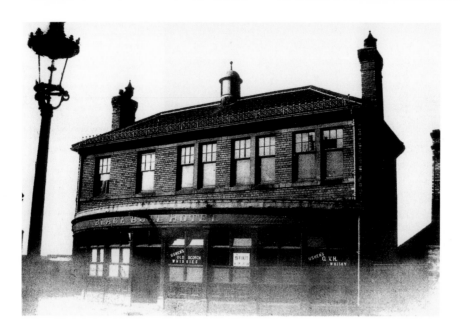

The Black Bull

Built in the early twentieth century to replace a much older cottage, this building originally had a bow window which can be seen in the old photograph. The window was removed at a later date although the outline of this can still be seen on the ground. Opposite the Black Bull is a lane called 'Fountain Lane'. Before 1860 Blaydon had no regular water supply, in that year Cowen handed over two drinking fountains for the villagers to use. They were housed on large stone columns and surrounded by railings. One was placed outside the Black Bull and it this structure that gives its name to Fountain Lane, which was formerly called Dockendale Road, though the lower part was called Chapel Road after a nearby Methodist Chapel on Bridge Street.

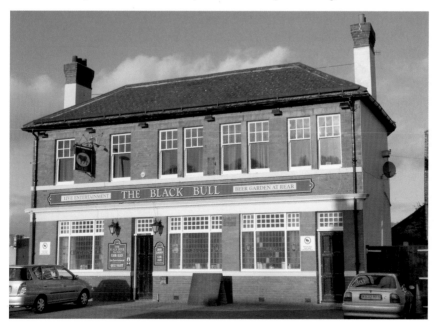

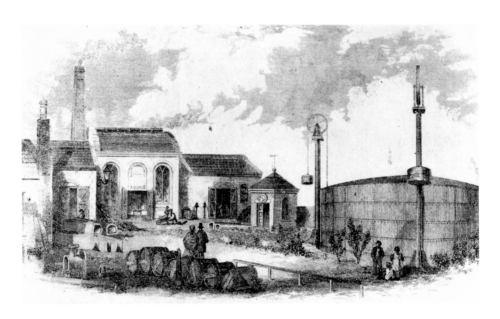

Gasworks

The gasworks were situated on Gas Lane behind the Black Bull. The works were established in 1853 when Sir Joseph Cowen extended his brickworks factory at Blaydon Burn into Blaydon itself, and he needed a means to provide light for his new works. The facility was extended to the rest of Blaydon much to the delight of the residents. The above illustration shows a gasometer of unusual design – notice the counterweights on the side. Part of the chimney and building on the left survive, it is now part of Oakleystone Northern and here (from left to right) are Thomas Piotrowicz, Kurt Riffert, Gary Toth and Bartek Hejmej.

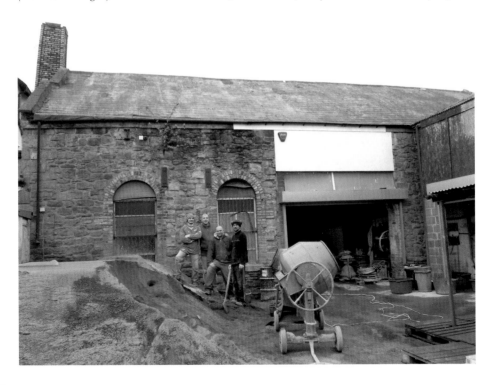

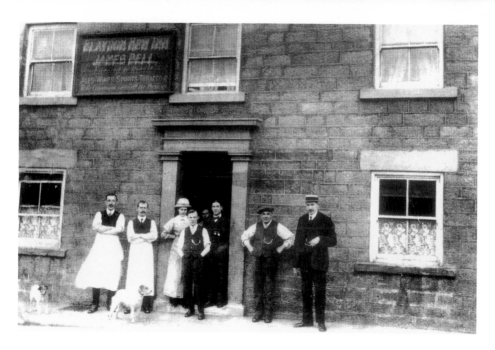

New Inn

Above is the original Blaydon New Inn with licensee James Bell and his staff standing outside. It was known as Bridge End and stood alongside the burn. Originally built of stone it was rebuilt in brick in the early twentieth century. The building housed Swan's salerooms for many years before refurbishment as office premises. It is now Sheridan Design and pictured outside are current inhabitants (from left to right) Patrick Sheridan, Rachel Short, Lisa Redpath, Jon Ternent, Lynsey Carr, Amy Jackson, Richard Hanley and Craig Wilson.

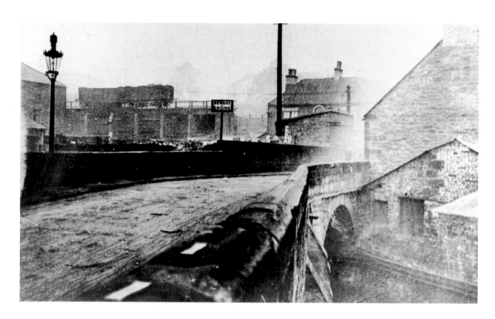

Turnpike

The turnpike road from Gateshead to Hexham passing through Blaydon opened in 1776 and the stone bridge across the burn was built in 1778. Tolls were paid to travel along the turnpike 2/- (10p) for coach passengers and 1d (about ½p) for foot passengers, except when going to a church service or funeral. In the old picture we can see the bridge and the coal drops left, and Crowley's warehouse rear centre. The sign advises us to 'Beware Engines'. The old bridge still remains, a new bridge and road was constructed in 1936.

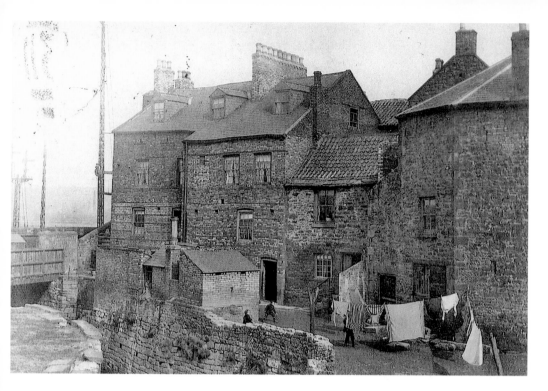

Burnside

When a Mr Nicholson died in 1865 it was reported that he had built three or four small sailing vessels at his yard near the mouth of Blaydon Burn, but apparently not much else in the way of boat building took place. The coming of the railways in the 1830s and the dredging of the River Tyne in the 1850s led to the decline and eventual demise of the keelboats and the men who had manned them. The Blaydon Burn seen left was culverted over for safety at this point, note the steep sided walls. On the far right is the back of the original New Inn, the replacement building is pictured in the new photograph.

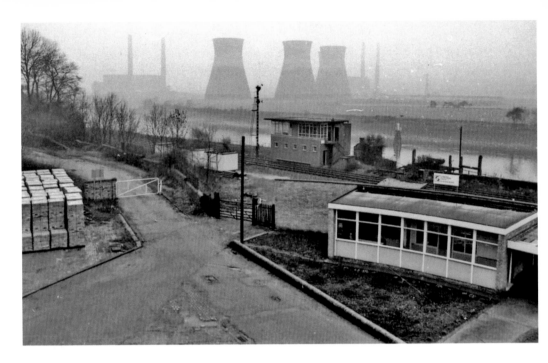

Cowen's Crossing

The railway crossed the turnpike at this point to link up with the main line. Cowen's bricks were transported by ship from Cowen's own quay down river. In the old picture we can see Stella Power Station which when built in 1952 covered the site of Blaydon Racecourse and Blaydon RFC. The site of the Racecourse was still visible up to this time even though the last race had been in 1916. The power station was closed in 1991 and demolished in 1996. Once a busy transport hub, a solitary cyclist now heads towards Blaydon Burn.

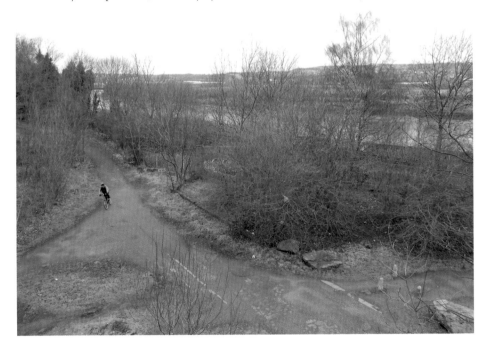

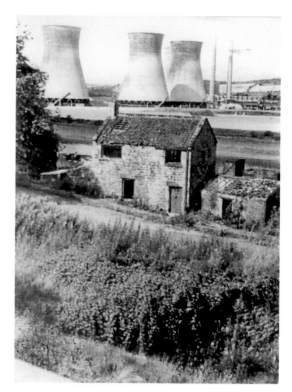

Toll House

A two-up, two-down toll keeper's house was built on the Stella side of the Burn to house the toll keeper and his family. There was one window facing the roadway to give the toll keeper a good view of everyone passing by. The house was later bought by the Blaydon Burn Collieries and used to house miners working at the pits. After the demise of the Blaydon Burn pits the house was used for a time by the Blaydon Sea Scouts and the Blaydon Boy Scouts later falling into decay before demolition around 1960.

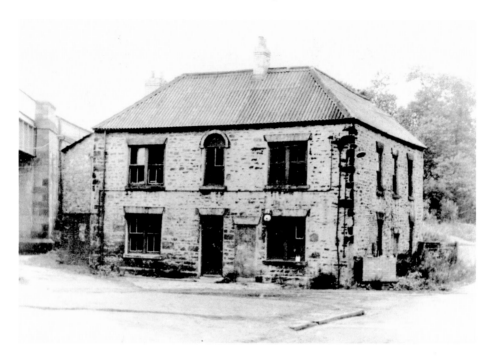

Crowley's Warehouse

This warehouse was built just by the bridge at Blaydon Burn around 1700 as part of Crowley's Iron Company; a newer corrugated iron roof has replaced the original. The old photograph must have been taken after 1936 because the new bridge constructed at that time can be seen on the left. While the bridge remains virtually unchanged, the warehouse was demolished around 1970 and all traces of it have gone.

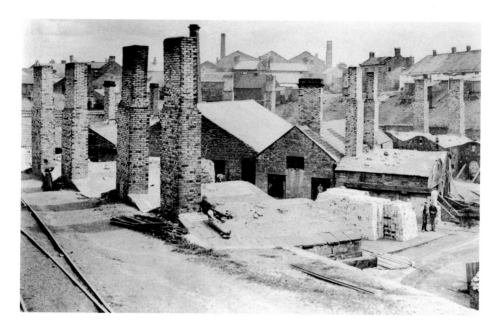

Low Brickworks

Sir Joseph Cowen senior made his fortune in the manufacture of brick and clay products; here is his 'low yard' at Blaydon Burn looking towards Summerhill, opened in 1838 on the site of Rennison's Mill. The works had eleven kilns and a good hand moulder could make 2,400 bricks per day. Mechanisation came in by 1926 and 1,200 bricks could be made per hour, all were stamped 'COWEN'. The brickworks usually employed about eighty workers and although export orders had dried up by 1955 they continued making common red house bricks until 1967. The yards finally closed in 1975 when the remaining stock was sold off at £15 per thousand. The site of the brickworks has now almost completely reverted back to nature.

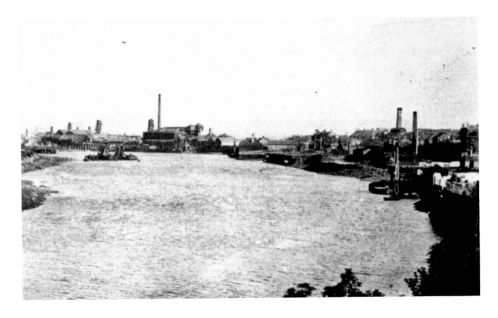

Blaydon Riverside

Above is the riverside at Blaydon, looking east in around 1901. This was where the industrial cargoes were loaded onto the small keelboats for delivery to Newcastle, where the loads would be transferred onto larger sea-going vessels. The main cargo would be lead from the mines at Allenheads, Rookhope and Feldon, and coal from the nearby mines in Blaydon and Winlaton. When the railway arrived in Blaydon many of the staithes disappeared, as coal could be more efficiently and quickly transported by rail. Other industries developed along the riverside, particularly around the Blaydon Haughs area. They included Blaydon Manure and Alkali Works, a lampblack works and a glass bottle works. Much of the heavy industry has now gone.

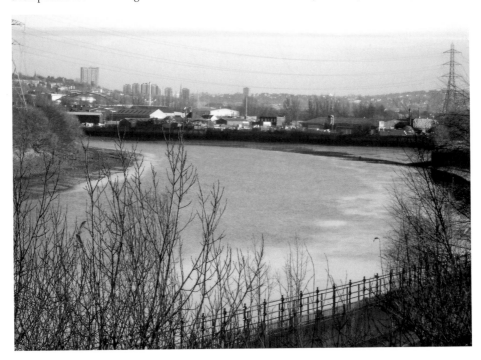

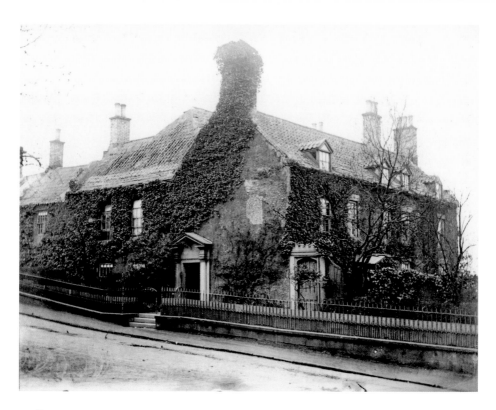

Stella House

Stella House dates back to the early eighteenth century. For many years it was home to the local coal owners the Silvertop family, the keelmen referring to it as the Rising Sun because of its position, the sun glinted on the windowpanes. It was later the residence of T. Y. Hall, inventor of the 'cage', a lift used to transport men up and down mine shafts with better safety. The old photograph shows the steeper incline of the old road leading to Blaydon before the construction of the new level road and bridge across Blaydon Burn. The front of the house, pictured to the right of the photograph, was removed in the 1960s for road widening although the remaining wing still stands.

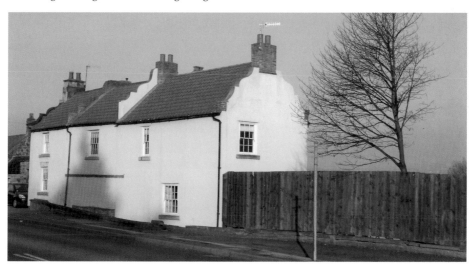

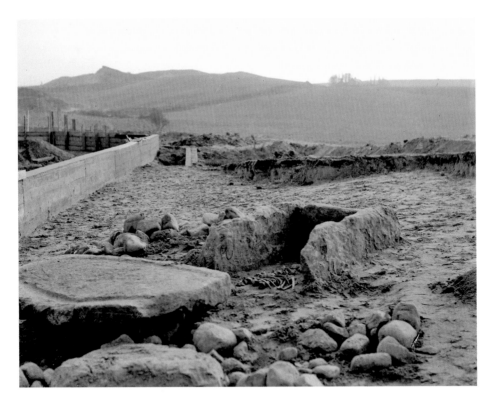

Cist on Summerhill

In May 1930 some boys playing on Summerhill unearthed a stone coffin (called a 'cist'). The coffin was measured at around 2 feet long, 3 feet 6 inches wide, and 2 feet high, and contained the skeleton of a man, and the fragments of a woman. The date of their burial was estimated to be between 1000–2000 BC. Eight years later more burials similar to the first were discovered in the sand quarry on the opposite side of the road. The hills in the distance are now covered in housing.

The Summerhouse

This is the summerhouse of Stella Hall, located on Summer Hill, pictured around 1910. Nearby stood a statue of Giuseppi Garibaldi, leader of the Italian 'red shirts' and much admired by Joseph Cowen. The Summerhouse was a large octagonal building originally with a domed roof built between 1700–1715 for the Widdrington family. It originally had glass windows but these were bricked up in the mid-1800s when the building began to decay. This Grade II listed building was at various times used as a shop and a school. Recreating the pose today is Georgina Neave, daughter of one of the authors.

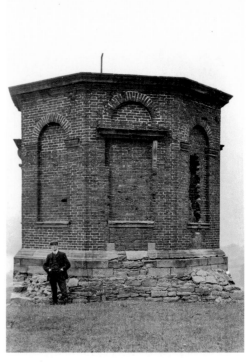

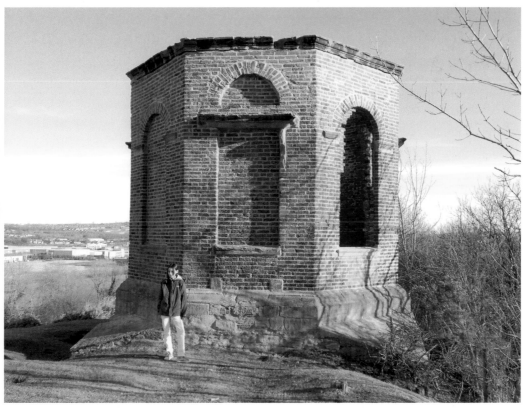

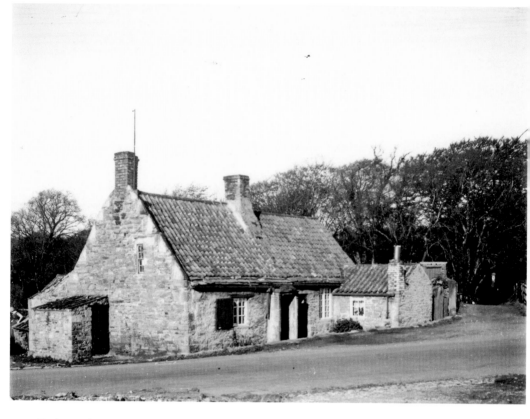

Path Head

Path Head village was once a thriving community of thatched cottages similar in appearance to the one pictured above. The farm and the corn mill formed the centre of the community; the farm was especially important as it supplied horses for the nearby coal mines and waggonways. A house that served as a toll house and then a general dealers is pictured above. It has since been demolished and replaced by new housing. The nearby Path Head water mill has been restored and is now open to members of the public.

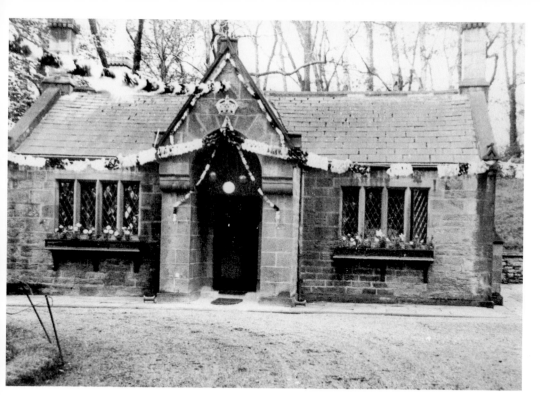

Stella Lodge

The estate of Stella changed hands many times. Historical records report that it was initially granted to the nuns of St Bartholomew in 1143, and a convent was constructed. After the Dissolution of the Monasteries in 1539 the estate was granted to William Barrantyne but around 1600 Elizabeth I passed the estate to Nicholas Tempest, and it is around this time that the original Hall was built. This is the Lodge to the Hall and apart from new windows and a roof it remains almost unchanged.

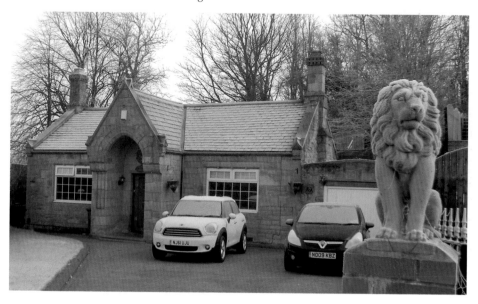

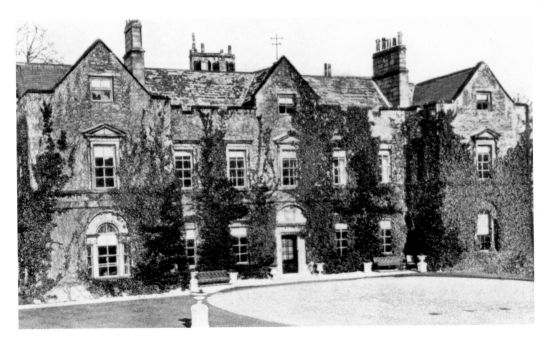

Stella Hall

The original Stella Hall was modified in the eighteenth century by architect James Paine who also designed Axwell Hall. The Hall and its park were sold to Sir Joseph Cowen in 1850. One famous guest was Garibaldi, a statue to whom was located in the gardens. The statue's head is now in Blaydon library. After Joseph Cowen junior's death in 1900 his daughter Jane Cowen continued to live in the Hall until 1946. After her death in 1948 the Hall was left to Durham University but was demolished in 1954 to be replaced by a housing estate; this is the approximate location.

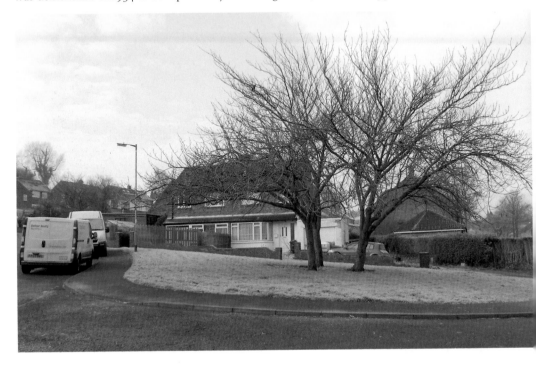

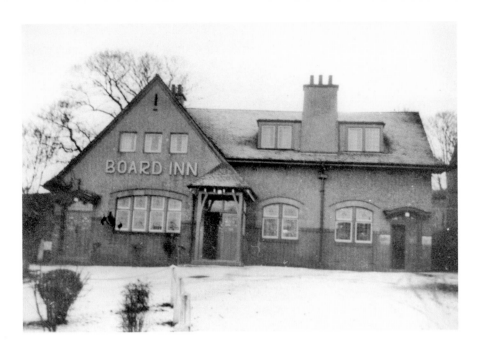

The Board Inn

Throughout the nineteenth century impromptu horse races were held at Blaydon on a stretch of flat land near the river, known as 'the Guards'. Over the years these races became more popular and attracted a travelling fair (a 'hoppings') that was located in the Spike. When the railway station was built in 1835 'the Guards' disappeared, and the race was moved to Blaydon island, becoming a formal event in 1861. The horses were stabled at the Board Inn and walked down to the site.

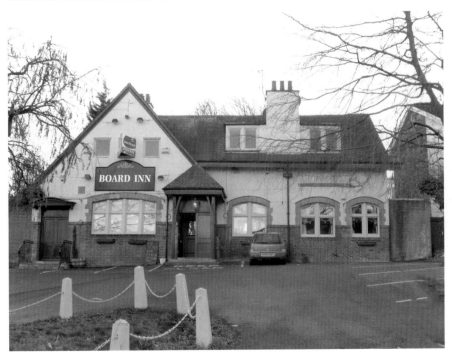

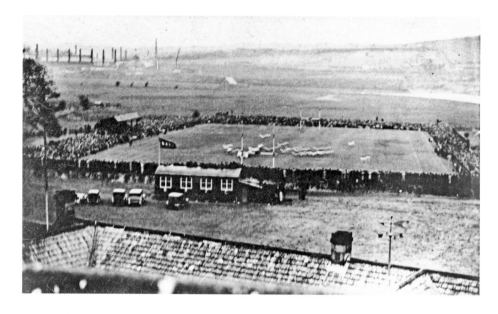

Howay the Lads!

Above we can see a match taking place at the ground of Blaydon RFC at Stella Haughs in 1932. The match was a County Final between Durham and Gloucester, with attendance estimated at 11,600; Gloucester won 9–0. The ground was purchased by the Electricity Board in 1951 in order to erect a power station; they originally offered £500 but the club held out for £1,000, and then paid the National Coal Board £350 to buy the land at Crow Trees to build a new ground and clubhouse. The River Tyne can just be seen in the background and for several years the club employed a boatman to retrieve errant balls from the river! A new housing estate is currently being built on the site.

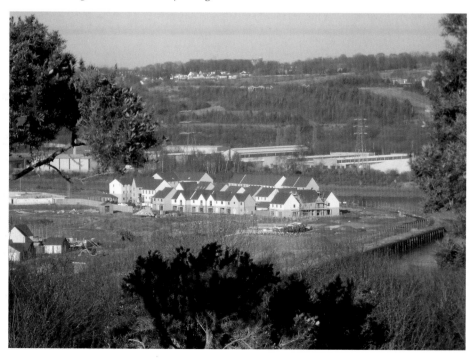

The Bessie Mine

The first mention of coal mining at Blaydon is found in the Ryton Burial Register where it is recorded that on 22 August 1628 Thomas Proctor of Blaydon and John Jobson of Winlaton were killed in a 'kole pit'. The Blaydon Main Colliery was established in the 1600s. It was closed by 1706 but was reopened in 1853 due to the great demand for workers Cuthbert and Robinson Streets were constructed to the north of Shibdon Road. The colliery had three main shafts, the Hazard Pit and the Speculation Pit stood at the bottom of Shibdon Bank, with the Mary Pit halfway up Blaydon Bank behind the Huntsman pub. This is the Bessie Mine, a drift mine located in Blaydon Burn in the 1920s. The Bessie pit closed in the mid-1950s. Here is co-author Susan Lynn in front of the remains of the coal drops which are opposite the entrance to the mine.

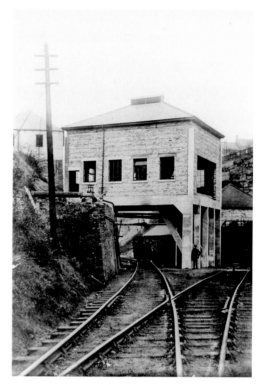

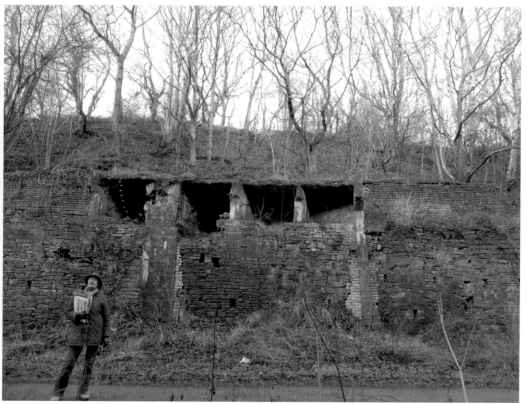

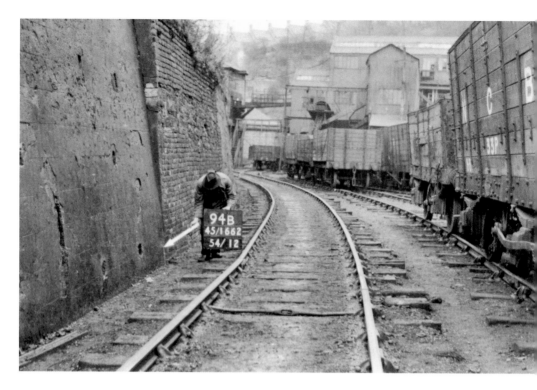

Strike a Pose!

It was unusual in this area for pictures of working mines to be taken. In 1952 the Ordance Survey conducted a survey of Blaydon Burn Colliery and here we have the Ordnance surveyor marking the position of a bench mark and accidentally capturing the working day. We can see the coal trucks on the right stamped NCB and to the rear the sheds of the Bessie mine linked to the coal drops. The wall on the left still remains and here former Mayor of Gateshead, David Lynn (husband of co-author Susan) recreates the pose.

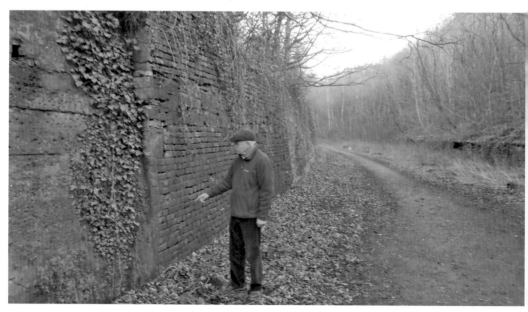

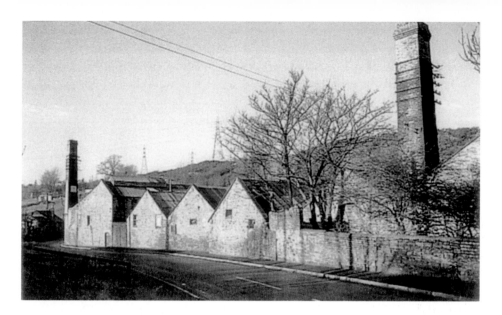

Cowen's High Yard

Foster's mill at the high end of the burn is shown on the earliest map of the area in 1632. Fire clay was worked at Blaydon Burn in the eighteenth century. Joseph Cowen joined his brother-in-law John Forster in business around 1820 and by 1835 had extended his works down the valley to the Low Yard. The brickworks arose because of the supply of coal. Fire clay occurs naturally between the seams of coal and fire bricks and gas retorts made from fire clay were needed for the great Victorian steam age. There were seven kilns at the High Yard. As well as bricks, the works made 'Mr Cowen's Celebrated Gas Retorts'. Cowen's invented the clay retort, used in the making of town gas which was found to be superior to iron. The remaining buildings are all in private commercial use.

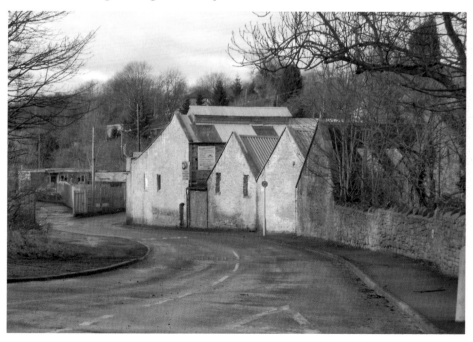

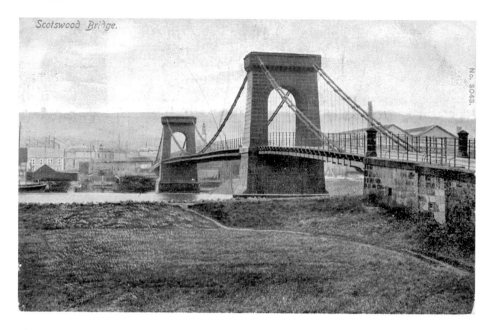

The 'Chain Bridge'

In 1827, the rector of Ryton, Charles Thorpe, organised a meeting with local landowners to consider the building of a bridge across the Tyne to connect to the Turnpike Road linking Gateshead and Hexham. The bridge was completed in 1831 at a cost of £15,000 and was one of the first suspension bridges in the world. It was 630 feet long, with the road in the centre being around 8 feet higher than at the ends. Work on a replacement began in 1964, 100 yards west of the original bridge, and it was officially opened by Alderman Peter Renwick on 20 March 1967. Part of the original foundations can be seen on the bottom left in the new picture.

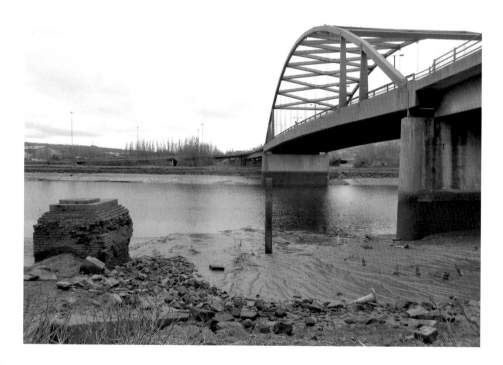

CHAPTER 2

Winlaton

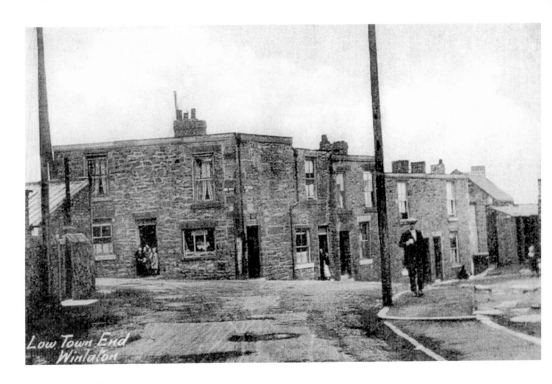

Low Town End

The old picture was taken in the 1920s and shows housing with flat roofs, most unusual at the time and presumably built for cheapness. To the right is North Street and to the left is the road to Blaydon Burn. To the right of the man in the foreground is the Rose & Crown. The last pair of flat roof houses to the left still exist, but with the addition of a more conventional hipped slate roof.

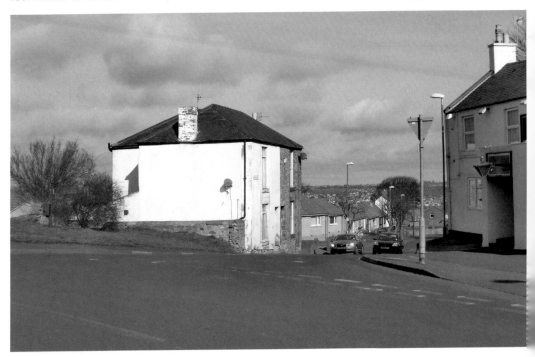

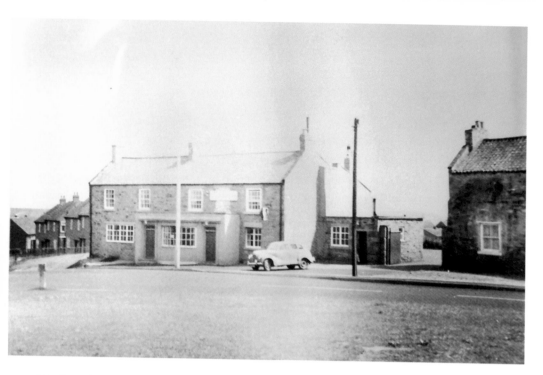

The Rose & Crown

Pictured around 1960 the Rose & Crown was nicknamed the Laa Toon End (low town end). During conversion a stone sill was discovered with the inscription 'Thomas Wall and his son rebuildeth this house 1656', the stone being hidden by later rebuilding work. This ancient hostelry was well situated at the road junction to Blaydon and Blaydon Burn. The pub was much altered in the late 1960s. To the right of the pub is Winlaton bus depot.

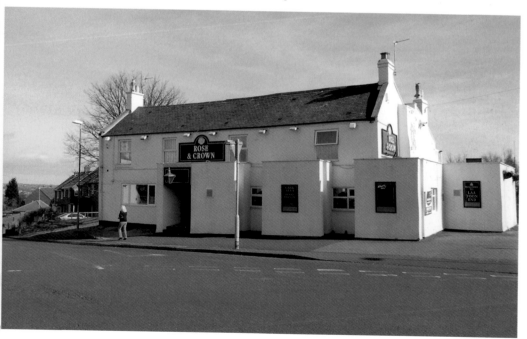

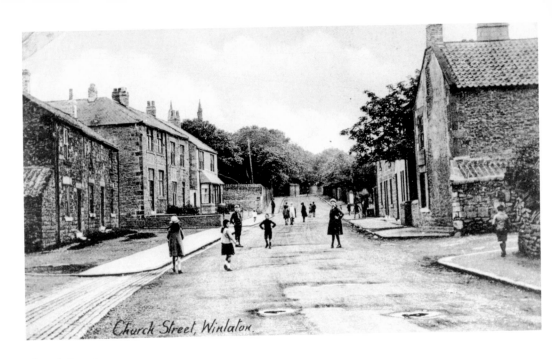

Church Street

The road leading towards St Paul's Church. On the left hand side of the road only the house furthest away from the camera survives. The road to the right is Caledonia, and what appears to be the original house on the right is actually the one behind it. It was along this stretch of road that the funeral processions of Sir Joseph Cowen and, resting on a gun carriage, the coffin of Col. John Cowen processed. Both were buried in the Cowen family vault at St Paul's Church. In 1900, John Oliver ('Coffee Johnny') was also laid to rest at St Paul's cemetery.

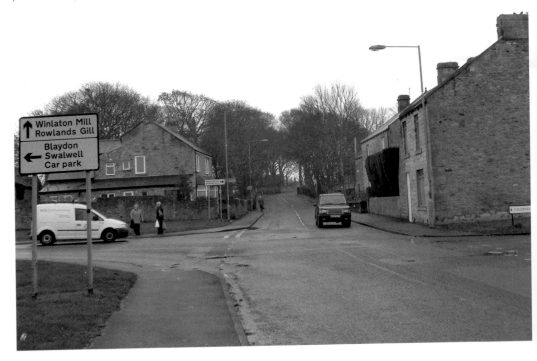

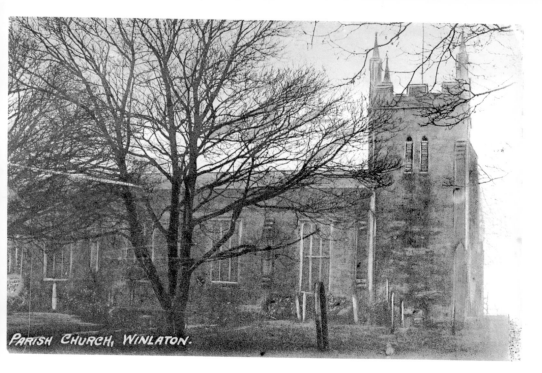

PARISH CHURCH, WINLATON.

St Paul's

Bull-baiting was a popular sport in Winlaton, and a bull-ring stood on common land where St Paul's Church now stands. The Rector of Ryton (Archdeacon Thorp), together with local landowners, decided that the church must take a more prominent role in village life and Thorp gave up part of his income from Ryton to provide the endowment for St Paul's. It was designed by Ignatious Bonomi and built in 1828 and was initially part of Ryton parish; in 1832 the church became a parish in its own right. The gravestones have all been re-situated around the walls of the graveyard.

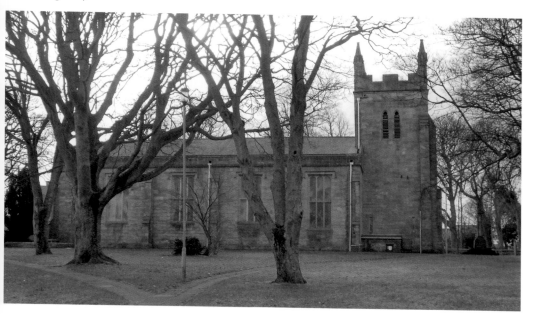

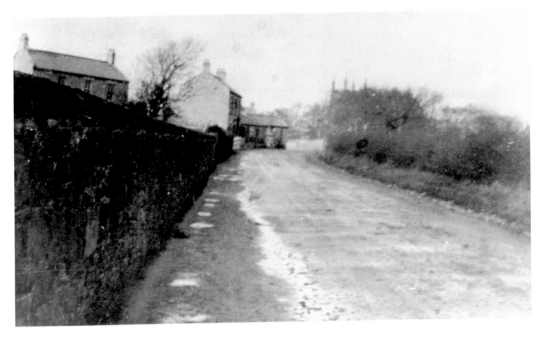

Scotland Head

Looking towards St Paul's Church just glimpsed ahead, through the trees before the bungalows of St Paul's estate were built to the left of the road in the 1960s. The second house on the left is Scotland Head House. The area is so called because on a clear day further down the road one can see the Cheviot Hills, once part of Scotland. To the right is the housing estate built by the local authority known as the Lakes.

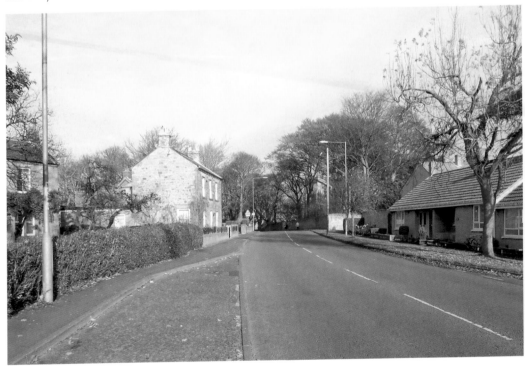

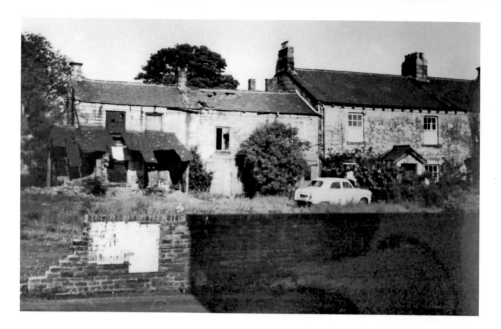

The Groves

Named after an early open-cast mining technique, known as groves, on the Westfield (Windy Fields) the houses to the left have all been demolished. Coal from the area was first mentioned in 1367 when 'sea coals from Wynlatone' were used in the burning of lime during the construction of Windsor Castle. The Winlaton Community Centre now covers part of this site to the left; the house on the right of the old photograph can still be seen.

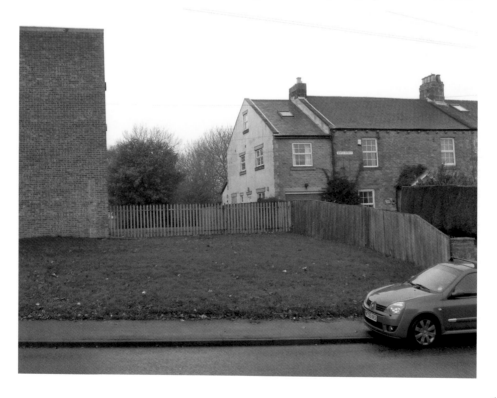

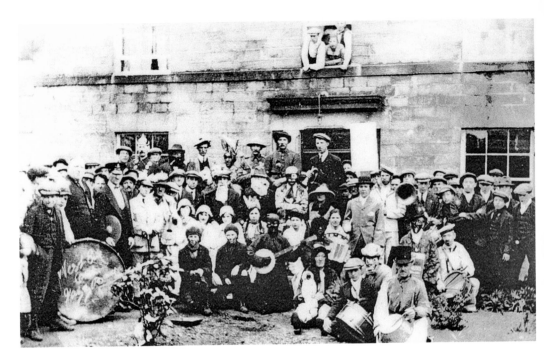

Caledonia House
Now better known as the West End Club, the old picture shows the West End Jazz Band in 1930. The original houses in Caledonia were largely built in the 1850s and the area was named because on a clear day Scotland can be seen. In the new picture are (from left to right) Bill Taylor, Robert Taylor, Red Skelton and Stewart Bilclough.

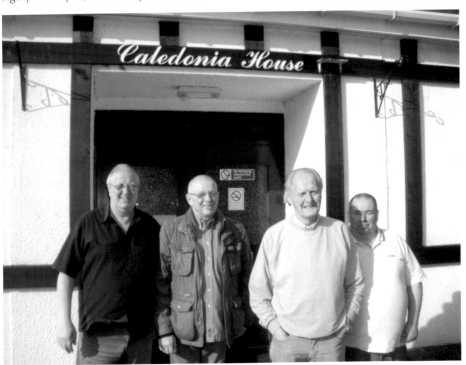

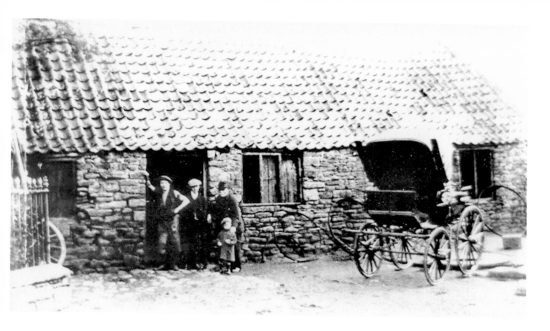

Rectory Lane

This was the site of Armstrong's blacksmith's shop. Ambrose Crowley set up business in Winlaton in 1690 with a series of small industries and cottages set up in squares, making nails, chains and other small iron ware. A strict curfew was in force and the workers all had to be in their squares at night, every aspect of their day was regulated by numerous laws. In the eighteenth century the working week was 80 hours and for this a skilled man could expect to earn 14 shillings (70p). Modern houses stand in the same spot as Armstrong's, and here can be seen Fiona and Patrick Murphy, and their daughter Caitlyn.

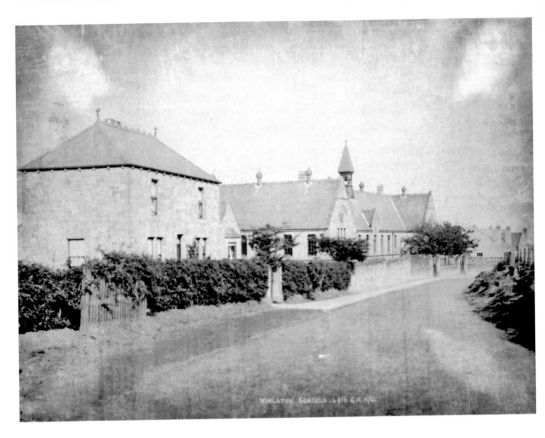

West Lane School

West Lane looking east. The Winlaton School Board was formed in 1875 and purchased land from Lord Scrafton in order to build the West Lane School. The house on the left was built in 1876 to house the Clerk of Works, responsible for constructing the school, and is currently owned by Mr Potts. The school was completed in 1876.

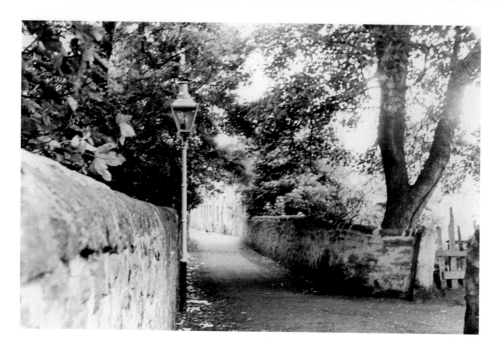

California

The old picture shows Half Fields Road with the entrance to California to the right. Behind the stone wall on the left is St Anne's Catholic Church, built in 1962. At that time this was a small lane, the road was widened and the new housing on the right was built in the 1950s. The first houses built in California date from the 1840s, mostly built by blacksmiths who had set up their own business after Crowley left Winlaton, an early example of working class men becoming property owners. They saw themselves as pioneers, like their American cousins, and called their street California.

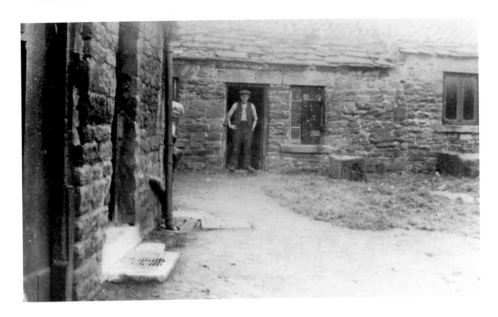

Hood Square Forge

Above is Richard Hurst (born in 1873) standing outside his forge in Hood Square. The building to the far right is the surviving building. The building behind Mr Hurst would once have been the living quarters of the blacksmith and his family but had been converted to working premises by the time the photograph was taken. The forge closed around 1950 and the remaining building is now owned by Gateshead Council and used as a small museum. In the new picture (from left to right) are ladies from Winlaton Library Stitchers' Circle.

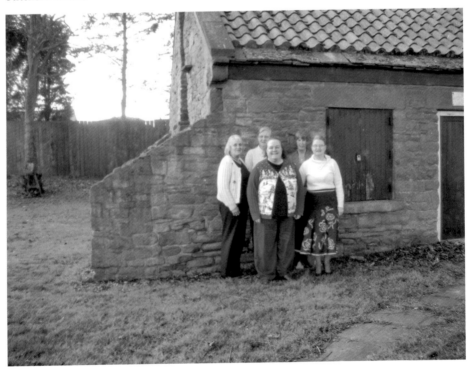

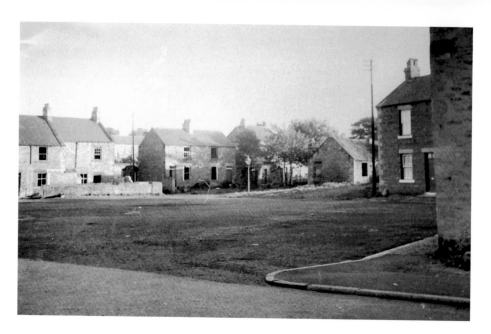

Hood Square Housing

The houses to the left and centre were demolished in the 1960s and new housing created on Hanover Drive. Hood Square is named after Admiral Samuel Hood, 1st Viscount Hood (1724–1816), known for his service particularly in the American War of Independence and the French Revolutionary Wars. He acted as mentor to Admiral Horatio Nelson and the British battleship HMS *Hood* was named after him.

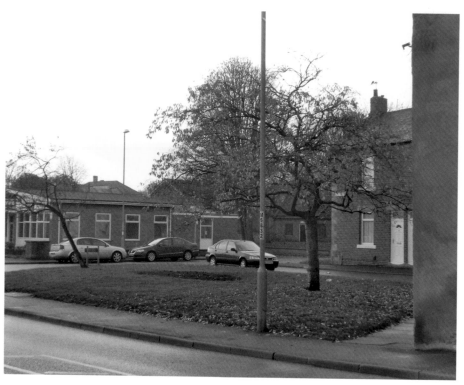

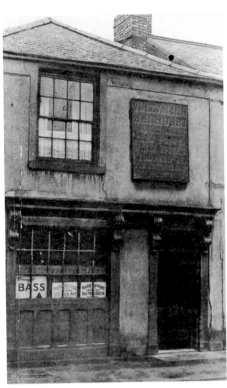

The Vulcan

This public house on Front Street was named after the God of Metalwork, most appropriate where the main source of occupation for 270 years was the trade of the blacksmith. The pub has been extended since the original photograph was taken.

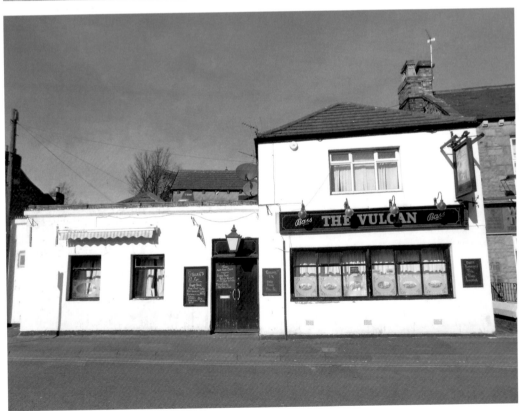

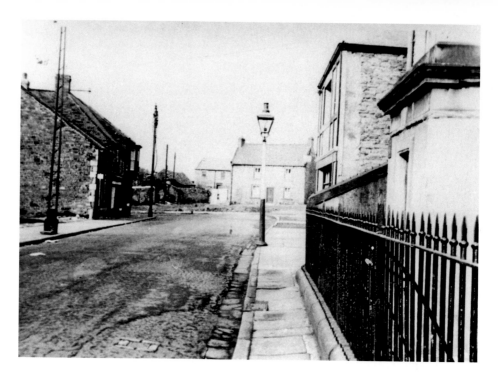

Brown's Corner

Looking towards Hanover Square. This area was called Harry Brown's Corner, and Brown's fruit shop is on the left of the old picture with the distinctive protruding bay window at first floor level. The stone flagged shop floor was below street level. Next left was Rowe's fish and chip shop. Top right is the Vulcan public house. The buildings on the left were demolished in the 1970s. The buildings and their railings to the right are still standing.

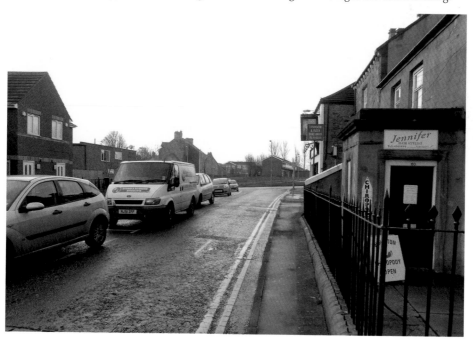

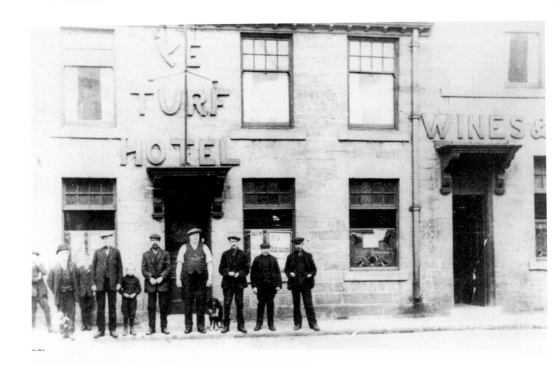

The Line-Up

The Turf Hotel was a nineteenth-century public house in Back Street. In a village of hard working blacksmiths there were once eleven public houses and almost as many churches. At one time Coffee Johnny (John Oliver), himself a Winlaton blacksmith, made famous by the song *Blaydon Races*, lived in Back Street with his family. Pictured here in the same location (from left to right) are Janet Ash, William Edgar, Billy Ballantine, Wilf Watkins, Ronnie Cross and Shannon Hands.

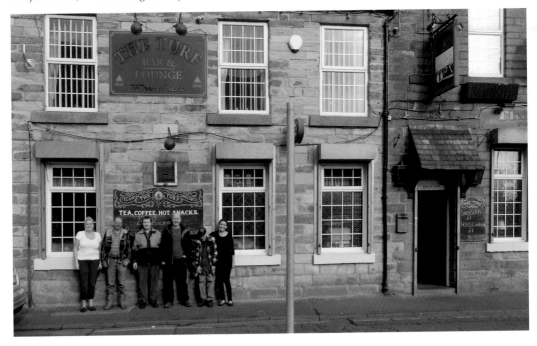

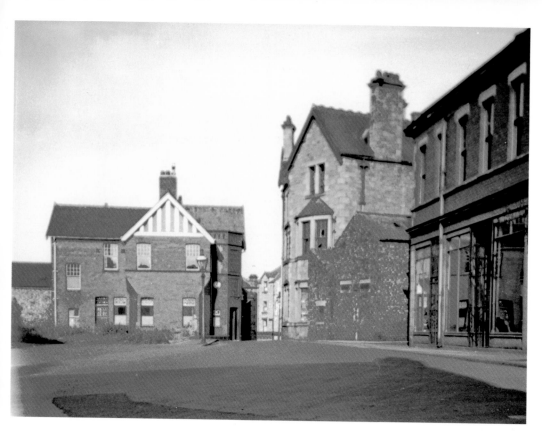

Two Pubs

The Crown & Cannon is front centre and at the right furthest away from the camera was the New Inn, which protruded so far in to the road it was demolished for road widening in the 1950s. Nearest to the camera on the right was a branch of the Blaydon Co-operative Society. The Crown & Cannon remains and the Co-op has been divided into separate shops, one is currently being refurbished and one is a bookmaker's.

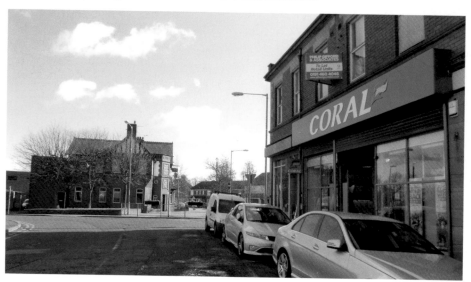

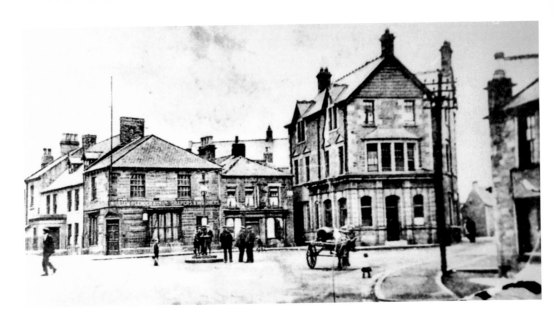

The New Inn

The building on the left is William Plender & Co., Drapers and Milliners. The large building to the right of centre is the New Inn built in the early 1820s. The landlord was John Cowen father of Sir Joseph Cowen. The Winlaton Blacksmiths' Friendly Society held their meetings here and Joseph Cowen was the first secretary in 1826. The Society was formed after Crowley's departure from Winlaton led to the loss of the social benefits enjoyed by the workers and so the remaining blacksmiths set up their own society open to their colleagues aged between eighteen and twenty-eight who could earn a competent livelihood.

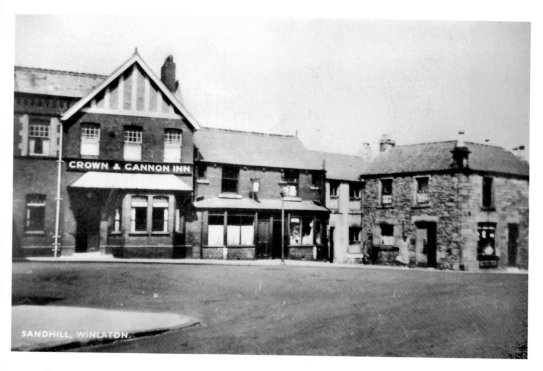

SANDHILL, WINLATON.

The Crown & Cannon

The Crown & Cannon was first built in 1780 and then rebuilt in brick in 1904. In November 1860 John Batey had his last drink in the original stone building before being murdered by 'Lanky' Smith at the top of Blaydon Bank. A mysterious red cross carved and painted on the stone wall marks the site at the top of Blaydon Bank where John Batey's body was discovered. 'Lanky' Smith was executed for this heinous crime.

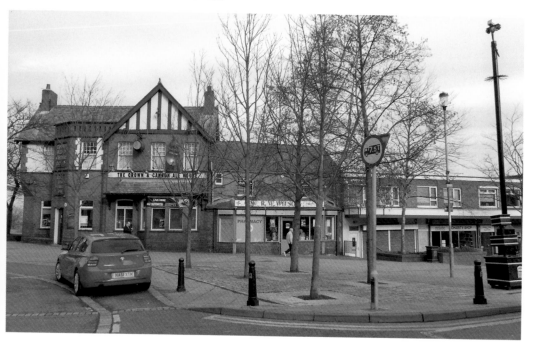

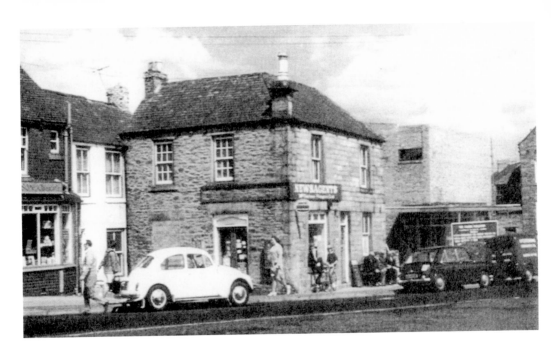

Newsagent

The picture above shows Front Street pre-1972. To the extreme left was a chemist owned by Mr Wilson, with Lloyds Bank just out of site. The stone building in the centre is McCutcheon's, the newsagent demolished in 1972 when the new parade of shops was built. The new Walter Willson store is under construction to the far right.

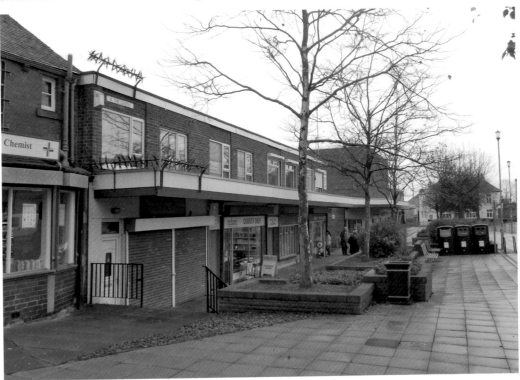

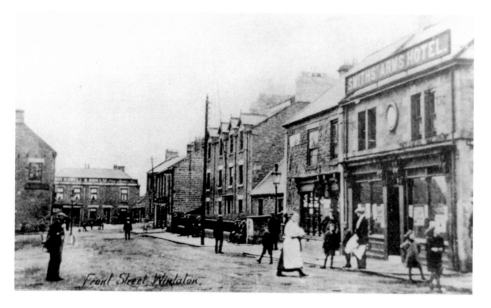

Front Street

Looking along Front Street. To the immediate right is the Smith's Arms, an eighteenth-century public house which also housed the village cockpit. It was known as the Clock in the twentieth century due to the large clock outside on the front wall but it was destroyed by fire in 1928. The eighteenth-century publican John Errington was also a brewer and an auctioneer. A desk sold in 1760 to a lady from Dockendale Hall at Blaydon Burn was found to contain a number of gold coins dating from the reign of James II, a fortune which set the woman and her neighbour up for life. Some of the original buildings remain on the right; the building at the end of the road is the Highlander which can still be seen today.

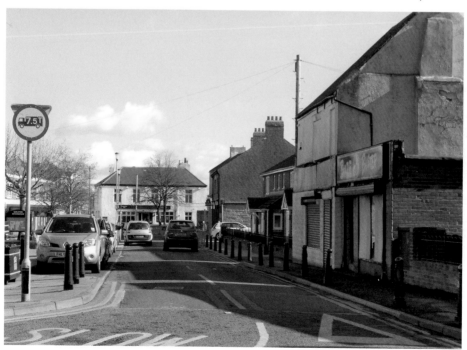

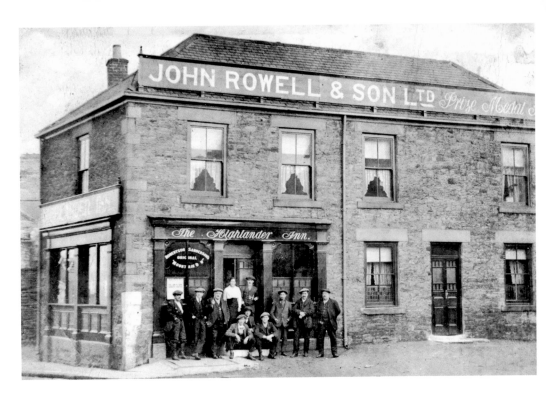

The Highlander

Built in the early nineteenth century, the Highlander also stands on Front Street. It famously hosted an event for the Chartist leader G. J. Harney in the 1830s; the room was hung with crimson and gold, a brass band played, and a toast was given to the 'health and happiness of the canny lasses of Winlaton', presumably the lasses who had provided the tea and cakes. The building has undergone considerable renovation but is still recognisable.

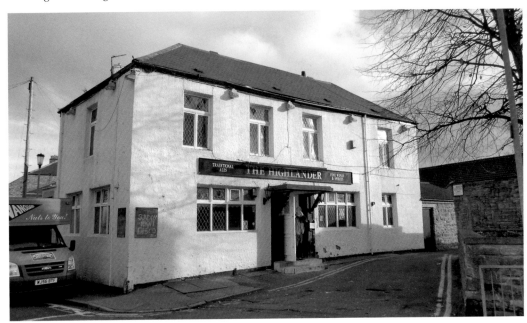

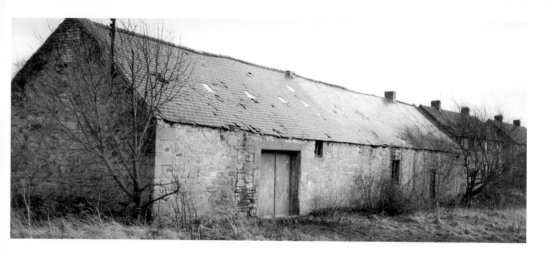

Knowledge Hill

Ambrose Crowley provided schooling for the children of his workers. It was most unusual for working class children to be given an education in the eighteenth century, leading to Winlaton being nicknamed Knowledge Hill. The workers paid into a fund to pay the schoolmaster who was also governed by Crowley's laws and under strict instruction not waste his time gaming or drinking when he should be teaching his pupils. Above is an old forge, latterly Sharpe's Joiners, on what is now Ambrose Court, just off Knowledge Hill, the street being thus named in the 1950s.

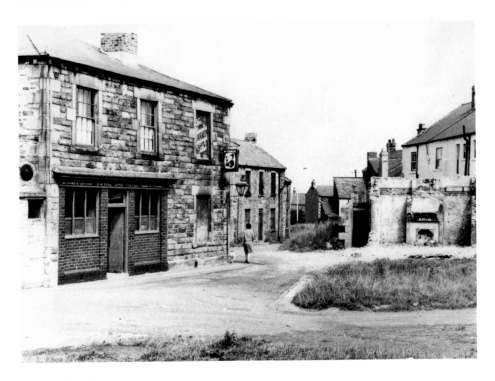

The Royal Oak

Winlaton's first Methodist services were ironically held in the Royal Oak in 1828 before their own chapel was built in Front Street in 1836, then they moved to Lichfield Lane in 1868. Winlaton was also the northern headquarters of the Chartist movement and their meetings were held here in the 1830s. The pub was known as Carsons after the landlord, or the Cricketers because it was the favourite haunt of the local cricket team. It was demolished in the 1960s, and only the white building to the right remains. This is the back of the Queen's Head.

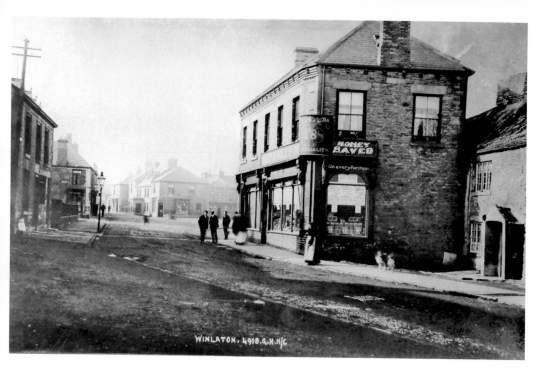

WINLATON, 4918. G.H.N/C

Walter Willson's

In the old picture is Walter Willson's shop, the notice on the end of the building proclaims 'money saved with every purchase'. The building far background centre was Plender's drapery shop, and left just beyond the lamppost with the distinctive chimney was Walker's general dealers shop. These two buildings can still be seen but Walter Willson's was demolished in 1972 to make way for a new parade of shops.

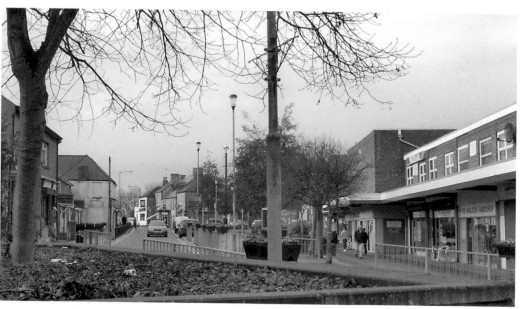

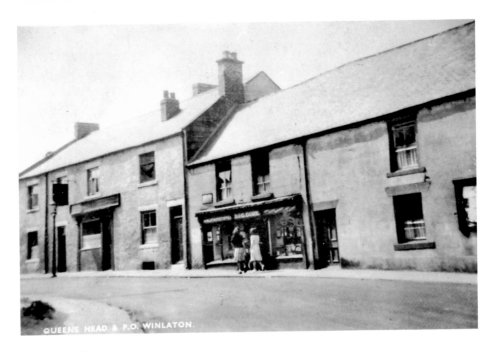

QUEENS HEAD & P.O. WINLATON.

Old Post Office

The Queens Head (left) and the post office (right). Note that when the rendering was removed from the post office two smaller and much older windows were revealed, the larger windows were possibly inserted at a later date to admit more light. The post office is now the Post House Takeaway and pictured outside is Stacey Parker.

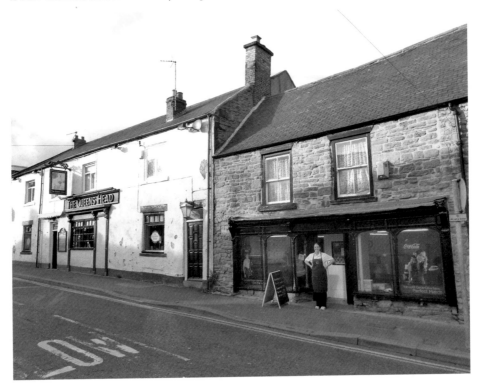

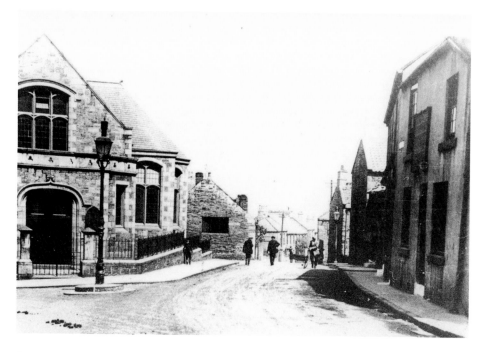

Front Street and Tebbs

This is the first site of Christian worship in Winlaton and the site of the first St Anne's Chapel which was burnt by the troops of Queen Elizabeth I in 1569 during the rising of the Catholic Earls. Later Crowley's Chapel and then the National School were on this site. The Congregational chapel on the left was known to all as Tebb's Chapel after the Revd Charles Tebb, who was Pastor for forty-five years until his death in 1918.

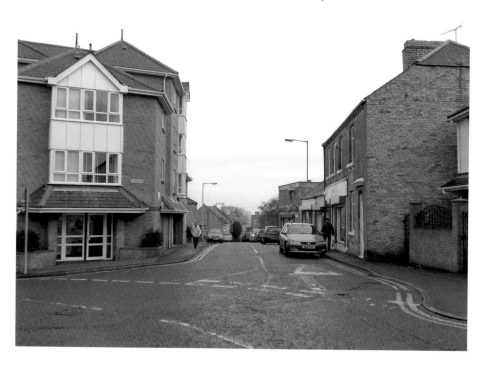

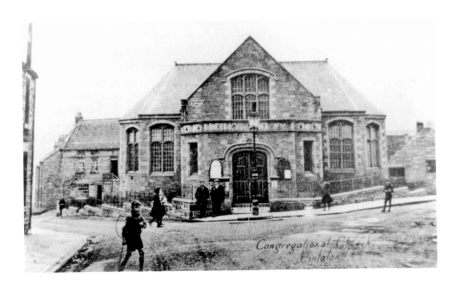

Congregational Church Winlaton

Tebbs

Another view of the Congregational Chapel built 1909. Just to the left can be seen Winlaton Hall. It later became a blacksmith's shop known as Crowleys & Belts Castle and was demolished 1928. In 1913 Mr Tebb said in a sermon that he would like to see the chapel free of debt (which stood at £200). The following Saturday he was at Blaydon station waiting for the train to Newcastle and spoke to Joseph Cowen (the son of Joseph the politician, and grandson of Sir Joseph). Cowen said that his sister, Miss Jane Cowen, had mentioned the debt to him, and that if he would come over to the *Chronicle* office he would write him a cheque to cover the £200. Mr Tebb fully expected to be able to surprise people with the wonderful news when he got back to Winlaton, but when he returned home that evening he found that everyone in the village had already read about it in the *Chronicle*!

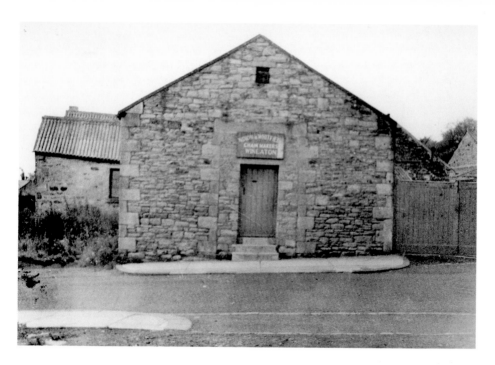

The End of an Era

This was Nixon & Whitfield's, the last working blacksmith in Winlaton which closed in 1966 at the end of a tradition stretching back 275 years. Crowley's work was mainly from government contracts for the British Navy. In Winlaton they made smaller ironware and sheathing nails which were used in nailing plywood sheaths to ships hulls. Ships away from home ports for long periods of time were found to stay more seaworthy if their hulls were clad in this way. The post office stands in exactly the same spot.

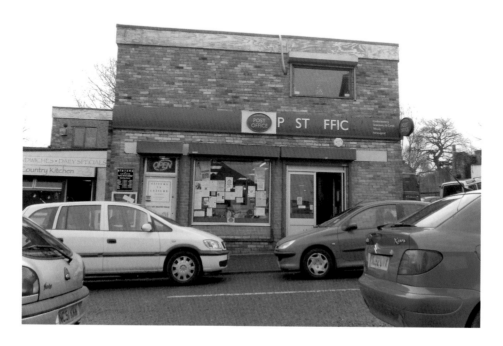

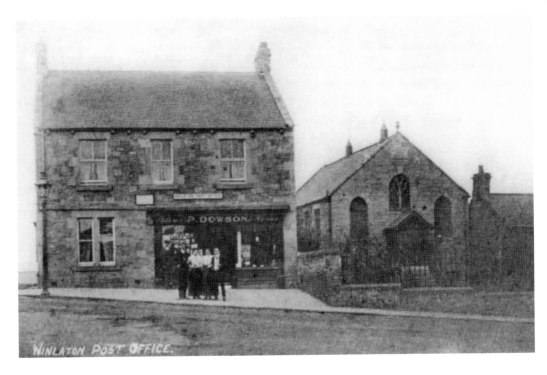

WINLATON POST OFFICE.

Salem Chapel and Dowson's

The Salem Chapel on the right was a Primitive Methodist Chapel, built in 1850 and enlarged in 1905. Winlaton was the head of the circuit for three years and was then was called 'a wild place' with a visiting preacher talking about preaching surrounded by the glare of the low roofed blacksmiths shops. There is a record of one sermon which began at 6 p.m. and ended at 3 a.m. the next morning! The chapel has been used by the Salvation Army since 1964. To the left was Dowson's post office. It is now a Boots pharmacy and is pictured with two of its current staff, pharmacist Martin Laing and Donna Richards.

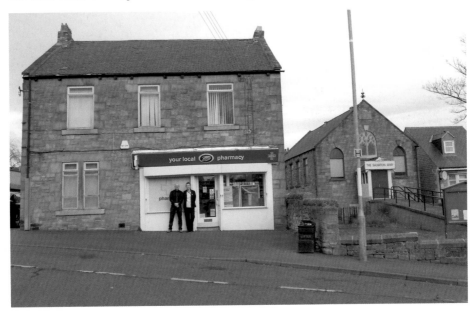

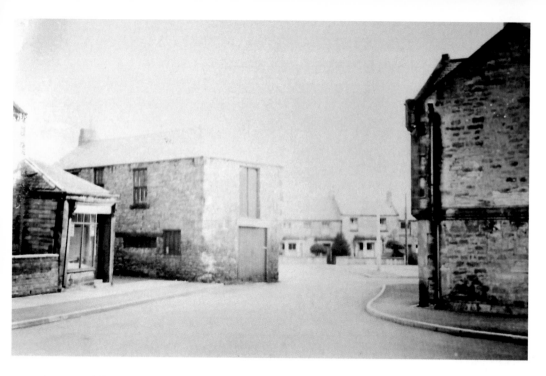

Commercial Square

To the right was a terrace of old houses and the house on the corner is still standing. The large protruding building on the left was used by a builder Wilfred Sisterson, noted for his wood carvings, and for growing and showing his prize chrysanthemums. These premises were used as a workshop and for storage, and have now been demolished. The houses in the centre of the picture have been combined to create the Hollyhurst Medical Centre.

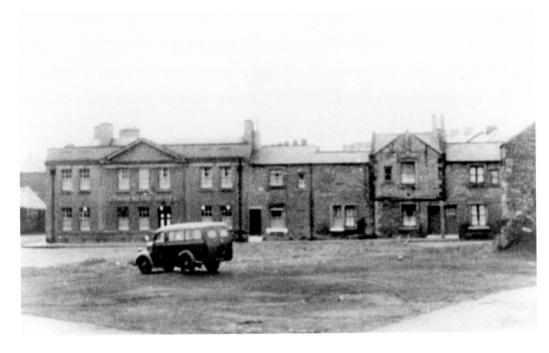

The Commercial

Above is the Commercial public house pictured around 1960; it was enlarged and refaced in the early twentieth century. The adjacent terraced houses originate in the nineteenth century and were largely occupied by miners. They remain almost unchanged apart from new windows and doors. At the far right was Sisterson's.

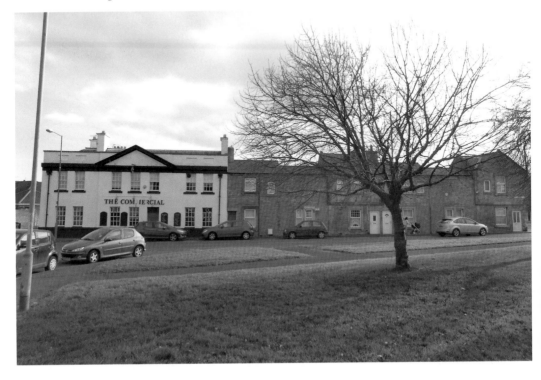

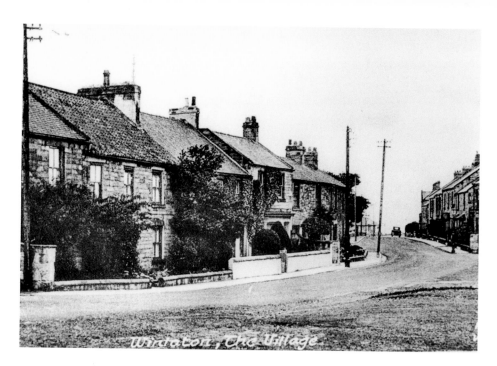

Winlaton, The Village

The Doctor's

The houses left nearest the camera were rebuilt to house a doctor's practice. In Crowley's time workers paid into a fund for medical care and for any medication prescribed. This had problems we would recognise today. Ambrose Crowley was angered at anyone feigning sickness and wrote, 'I have not forgot Thomas Haydon, who was too sick to work, but well enough to bait the bull.' The houses remain a health practice.

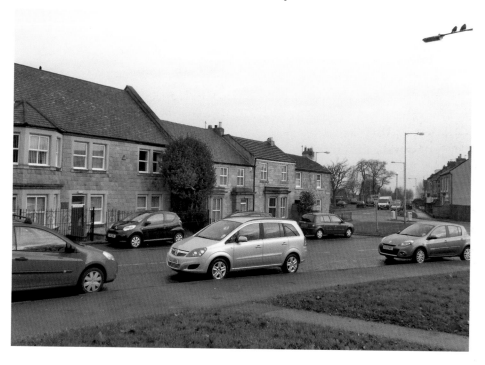

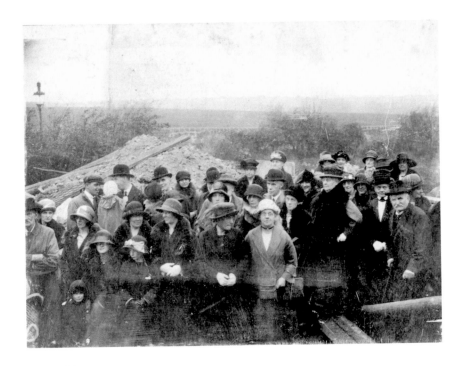

Litchfield Lane

A group of ladies and gentlemen gathered for the unveiling of alterations to the Wesleyan Methodist Chapel in Litchfield Lane, pictured in 1923 before the building of Zion Terrace beyond the stone wall. The Wesleyan Methodist Chapel was built in 1868 replacing their earlier chapel in Front Street, which had been built in 1836. The chapel has now closed and converted to housing, the congregation having now merged with the United Reform Church.

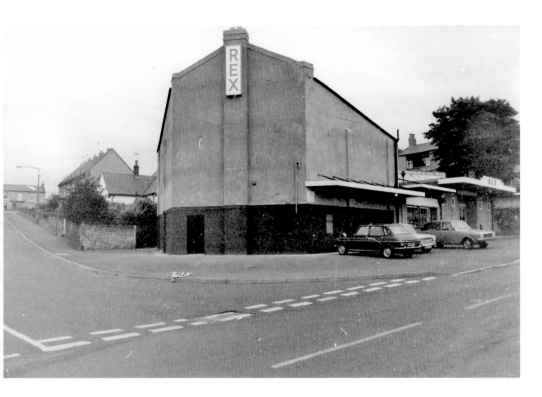

The Rex

The Rex cinema pictured in 1977. It was built in 1937 when visits to the cinema were at their height. A popular local venue remembered fondly by many, it later succumbed to national trends becoming a Bingo Hall until its demolition. The site now houses a block of one- and two-bedroom apartments but the design of the new houses is remarkably similar to that of the cinema.

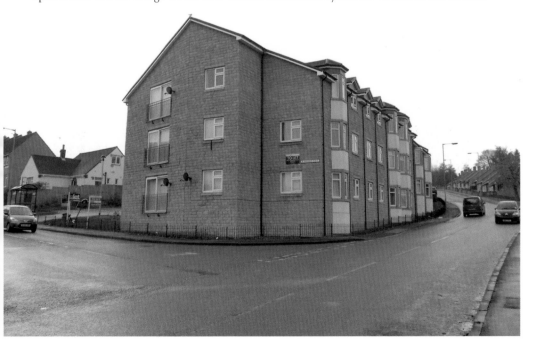

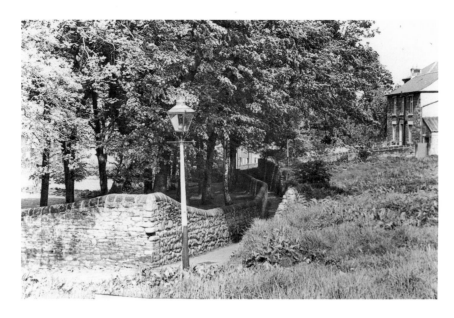

Love Lane

This lane still runs alongside the Hallgarth Club although the buildings to the right have been demolished. It is said to be haunted by the ghost of a servant girl pining after a lost love. Her beaux, a young miner from Blaydon Burn, had lost interest on being told she was pregnant. She waited for him each evening hoping for a reconciliation. Sadly, both mother and child died when the child was born, but the sobs lingered on, and even grown men were fearful of walking down the lane at dusk. They do say the sobs stopped when the miner was killed in an accident at the pit but many still feel a ghostly presence in this lane. The stone wall once housed the gardens of Hallgarth Hall, and is now used as a play area.

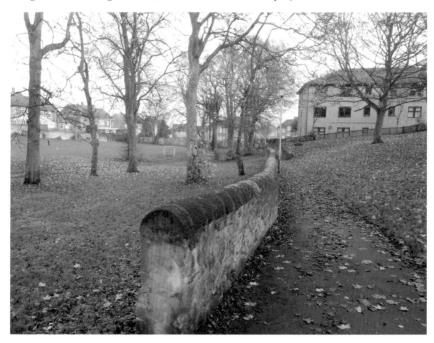